The Declaration of You!

How to Find It, Own It and Shout It From the Rooftops

Jessica Swift and Michelle Ward

NORTH LIGHT BOOKS

Cincinnati, Ohio
CreateMixedMedia.com

Contents

Hola! Wilkommen! Welcome! Yo! (a short intro)

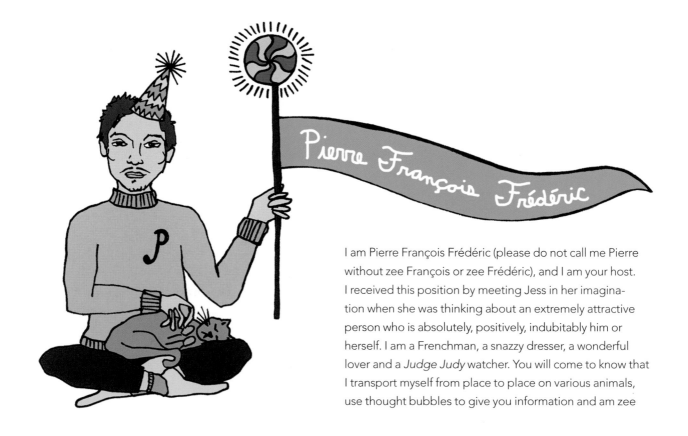

I am Pierre François Frédéric (please do not call me Pierre without zee François or zee Frédéric), and I am your host. I received this position by meeting Jess in her imagination when she was thinking about an extremely attractive person who is absolutely, positively, indubitably him or herself. I am a Frenchman, a snazzy dresser, a wonderful lover and a *Judge Judy* watcher. You will come to know that I transport myself from place to place on various animals, use thought bubbles to give you information and am zee

official host here at *Zee Declaration of You*. You probably won't come to know that my favorite meal is lobster mac and cheese, my favorite song is "Zee Sign" by Ace of Base and my favorite place is in a sauna, but I feel it is important information for you to have.

Although I am your host, Jess and Michelle will be writing zee rest of this book. I have parties to go to and animals to ride, after all. But this! This introduction is mine! And I, Pierre François Frédéric, will tell you how this *Declaration of You* came to be.

See, Jess and Michelle are prime examples of how zee Interwebs can lead to awesomely fantabulous friendships and super coolaborations. (Yes, coolaborations. It started as a typo, but is not anymore. I know it is a made-up word, but what can you do? Americans!) While they are not sure exactly how they found each other (zee blogosphere? zee twitterverse? zee sauna? no, definitely not zee sauna), after they met virtually, they e-mailed a katrillion times a day about everything under zee sun. Then Jess became psychic and asked Michelle to collaborate with her on "some sort of workbook—full of brilliant, coach-y wisdom and colorful illustrations, with stories, fun things to make, feel-good exercises and all kinds of good stuff!" Michelle responded intelligently, "Duh!" (I was just keeding about zee "intelligently" part, obviously.)

And so, a colorful coolaboration was born, and you are reading it now.

Zee three of us are here to give you permission to continually discover and follow your own unique path while slaying zee vampires (zee ones who suck zee good stuff right out of you) that get in zee way. Zee three of us are here to make sure your life consists of doing what you *love*, embracing your *uniquity*. We're here, too, to make up words and have a marvelously good time and bring laughter and color into this could-be-scary process.

Oui, oui, it's a tall order. And non, we cannot claim that we have it all figured out or that this is an end-all, be-all process with guaranteed results. But that's what's so exciting, and that's why we're here—to encourage and help and support you in discovering what this all means for you: your lessons, your life rules, your mission statement, your values, your declaration—of *you.*

So make zee commitment now to take zee "shoulds" that will pop into your head and throw them out zee window; to take zee But-That-Ain't-Possible/Practical/Real and kick it to zee curb; to take zee mask you wear out in zee world and rip it off your face and throw it into zee fire with a guttural scream. From zee moment you start *Zee Declaration of You* until zee moment you read zee last word, you need to promise us that you will solely be yourself. If you want to curse, curse. If you want to doodle unicorns, doodle unicorns.

Above all, this is your safe, honest space and this book is your canvas. Each of zee eight chapters contain worksheets, projects and interviews galore to guide you toward you own declarations around enthusiasm, trust, money, celebration and more. We don't want you to keep this book pristine. Instead, answer zee juicy questions and fill in zee gorgeous worksheets right here—you can write, collage and paint right on these pages!

While you'll come up with a declaration for each topic, at zee end of zee book, we'll assist you with coming up with a one-page declaration that covers it all. Magnifique!

Go forth, lovely unique you, and keep zee words "experiment" and "fun" close to your heart and in zee forefront of your mind. Write those words on every page if you need to, or write them on zee thumb of your writing hand so you can see them as you make your way through your Declaration.

Now I will turn zee book over to Jess and Michelle because Judge Judy is on zee television. But never fear! I will be back throughout your journey to show you my outfits and help you with your declarations. I will be with you every step of zee way, coolaborators all!

DECLARATION 1

ENTHUSIASM

ENtHUSIASM ●●●●●●●●●●●●●●●●●●●●●●●
(discover it)

You are allowed to like whatever you want, JUST BECAUSE, no reasons or excuses needed.

How's that for an opening? We believe in it so strongly that we have to bold it, open our book with it, and say it again: You are allowed to like whatever you want, JUST BECAUSE, no reasons or excuses needed.

Now, think about something you love that you wouldn't necessarily want to tell anyone about.

Real Housewives marathons.
Your Loch Ness Monster theories.
Your teen idolization of Kirk Cameron.
Your current idolization of Justin Bieber.

Sometimes we like things that we think we "shouldn't" like. (BAN "shouldn't" from your vocabulary from this moment forward!) But, the bottom line is that we like them, and there's absolutely nothing wrong with that. Not only is there nothing wrong with that, but it's what makes you *you*, and that's worth discovering, owning and shouting from the rooftops. (By the way, shouting doesn't have to mean literally shouting. We just want you to own it, and go confidently forth with it into the world!)

We're meant to be happy. Each and every one of us deserves it. Even if you think you don't deserve it and you have a laundry list of reasons why you don't, YOU DO.

When you're happy, you're putting your best self forward, sending inspired and passionate energy out into the world to affect all the other people who come into contact with you. We think our mission as humans is to be the best people we can be and to love each other, and we believe that can only occur when we're living the life that we're meant to live.

So if you're having a hard time embracing the idea that you can go down your own path (or give yourself the time and space to explore what you might love to do) for your own happiness, consider this: In embracing your own happiness, you're helping other people give themselves permission to be their own happiest selves. That's an important job, isn't it? And we each have it! We each have a unique formula to be our happiest and best selves, and shying away from it takes something away from not only you but from everyone in your world!

We think this happiness formula starts with defining our Big Likes. You can call your Big Likes whatever you want: passion, enthusiasm, interest, hobby . . . whatever word gets you into the mind-set. We realize everyone has her own association with words, which is why we encourage you to explore this. Basically, we want you to think about what makes you feel EXCITED. And "I don't know . . ." isn't an answer because *everybody* likes doing *something*. There are no wrong answers.

Maybe you really like to shop, but you're thinking, "My passion can't be shopping!" Or maybe you love to eat (note from Jess: Ahem, this is me), and you think, "But loving to eat? That's just being obsessed with food, not something I'm passionate about!" To which we say: Who the hell cares? Do you like it? Do you get excited about it? Great! Write it down on the worksheet that follows.

Confession from Jess—

Sometimes when I go to bed, I get really excited about getting to eat breakfast in the morning. You think I'm joking? Nope. It's true. I love to eat!

Write down the things you love and the things you love to do. If "love" is too strong a word, think of your "Big Likes." (Use the space on page 10 if you like.) If you're really, really, truly, honestly coming up with a blank, throw a notebook in your purse/pocket and carry it with you. Whenever you're having fun, looking forward to something, feeling happy/useful/un-self-conscious/free/in touch, or see time go by at warp speed, write it down. It can be as simple as drinking a glass of wine in your backyard or as big as throwing your mom a surprise party with one hundred people. No holding back! Use the first column on the Why I Like What I Like worksheet and get it all down!

When you're done filling in column one, sit with the list and ask yourself, "What is it that I love about each of these things?" Jot these things down in the middle column. In the right column, write how each item makes you feel. Be as specific as possible.

Be selfish with the things that make you tick! Embrace them! Nurture them! We want you to be as happy as you can possibly be. (Happy people are the most fun to hang out with, just so you know.)

Jess says—

So, you now know I'm passionate about breakfast. I love breakfast dearly, and I eat it right when I wake up every morning. I make a smoothie pretty much every day, but not your ordinary, run-of-the-mill smoothie. My smoothies are concoctions made from things like bananas, spinach, parsley, soymilk, yogurt, flax oil, flax seeds, avocado, grapes and milk thistle. Are you grossed out? I know. My husband doesn't know how I drink it, but I'm telling you, it's delicious! (I think I have different taste buds than many people.) Anyway, I love starting my day this way. A smoothie followed by a cup of Earl Grey tea, and I'm ready to go. This is one of the pieces of my life that makes me tick. Some people (ummm, my husband) think it's weird, and I don't care because I love it. What do I love about it? Well, for one, it's pretty fun to blend things up in the kitchen and see what I can come up with! Plus, it offers me an opportunity to treat my body nicely. How does it make me feel? I love it because it makes me feel healthy.

So you see? We're not necessarily talking about huge, lifelong, heart-on-fire passions here—though you can include those, too—but we're talking about all the little pieces of you that make up your life.

So, now that you've written down some things that you're excited about, maybe you're not feeling satisfied with your list. Maybe you have an internal, "But I don't really *know* what I like to do" dialog running through your head because you haven't allowed yourself the space to explore your interests for such a long time. That's OK! Take a few minutes to think about some things that pique your interest.

Have you recently been intrigued by yoga, but you haven't ever tried it? Maybe you think learning how to play an instrument could be kind of fun? What about just changing up your morning routine a little bit to see what changes in your life? Embrace the word "experiment," and make note of at least five things that you wanna try. Scratch that—we're not even going to go that far yet. Make a note, instead, of at least five things that you *might* wanna try. Use the Things I Might Want to Try worksheet to jot down your *might*-wanna-try ideas.

TOPIC: Why I Like What I Like

things I love/big like	what do I love about it?	how does it make me feel?

Want to know the method behind our madness? The reason we asked you for the "why" is that it's probably not the actual task that enthuses you, but the reason behind it. Going back to Jess's smoothie example, the actual smoothie isn't really what she loves—it's knowing that she's starting her day in a healthy, delicious way, and that's what revs her engine. Do you see any threads between the reasons behind the things you *might* wanna try and why you love the things that you *know* you love? What drives you to do something that you want to do and/or try something new? What are the components? The emotions? The results? Sum 'em up by finishing the following sentence:

I like what I like because what I like causes me to feel _____.

Which leads us to your very first declaration! Using the statement you wrote above, declare below how your socks get rocked!

ENTHUSIASM DECLARATION

I declare that doing things that make me feel _____

_____makes me tick!

I like what I like just Because:

(List your big likes here!)

TOPIC: Things I Might Want to Try

I might want to try...	because...

Since this is our very first Extra! Extra! section, we want to tell you what it is and what you need to do with it. (Helpful, right?) When we were writing this book, we basically had a katrillion exercises for each topic, and we were afraid that your head would explode if we gave 'em all to you. So, we took what we thought was the one exercise that would lead you to a focused declaration for that topic and took out the rest. But when we did that, we were sad, and the exercises were lonely. We thought about the possibility that you might need more exploration to find your declaration and/or more ideas to enforce it. So *voilà*—the Extra! Extra!s were born.

It goes without saying that these exercises are not mandatory, and it's entirely up to you to decide if you want to do one/some/all/none of 'em. Feel free to take Extra! Extra! ideas and run with 'em, or give 'em a once-over and move it along.

Stretch and Learn

Spend some time researching a class to take on something new that's struck your interest, even if you feel like it doesn't fit the outside image you've been told to portray. How fun would it be to learn how to play the ukelele or belly dance or learn Final Cut Pro? If you're having trouble figuring out what you want to do, think about the types of books and articles you read or what you watch on TV. Someone obsessed with the DIY Network might want to look into a woodworking class, while someone who is trying to live a green lifestyle can take a weekend class on, uh, living a green lifestyle. Commit to trying something new and actually do it. Take a look at the calendar and schedule it, even

if it won't happen for a few months (although the sooner, the better).

Shake up your routine. Pick one new thing to try each week, and do it every day for that week. Maybe you want to wake up early and do yoga before you go to work. Do it every day! Maybe you want to start a gratitude list and write five things you're grateful for each night. Do it every night for a week! Make a weekly schedule for how you're going to shake things up and stick to it. Plan for as many weeks as you'd like! (We think three or four weeks is a great start.) Experimenting with new routines and practices will get your brain moving in new directions and nip your ruts in the bud. Bring on the new!

Scary and Exciting

We've realized that the thing that is both scary *and* exciting is the thing most worth pursuing. Let us repeat that, bolded and italicized: ***The thing that is scary AND exciting is the thing most worth pursuing.*** Upside-down roller coasters: scary (10) + exciting (2) = "Oh, heeeeell no." (Note: That was from Michelle. Jess is less of a wuss.) Being an entrepreneur: scary (8) + exciting (10) = "All systems go!"

Use the first column on the Exciting and Scary worksheet to list the things that keep popping into your head but that you're scared of. Use the second column to rate it by its level of scariness (1 is a kid in a Halloween costume or whatever the least scary thing is for you, while 10 is the dark or whatever the scariest thing is for you) and the third column to rate it by excitement (1 is a lecture on microphysics or whatever the least exciting thing in the world is for you, while 10 is skydiving or whatever the most exciting thing in the world is for you).

Circle the "I want tos" that get above a 5 in both columns. Then think about the nicest way you can accomplish each "I want to." Would that trapeze class be less scary if you made it part of Girls Weekend? Would being an entrepreneur be more exciting if you invested in a shared space with other awesome entrepreneurs? Once you've decided on a pursuit and made it a bit safer, take itty-bitty baby steps to make it work.

TOPIC: Exciting and Scary

I want to...	Scaryometer (1-10)	Excitingometer (1-10)

ENTHUSIASM (own it!) ●●●●●●●●●●●●●●●●
Leonie Dawson

TDOY: *Included in the first line of your About page is, "I'm far too exuberantly overexcited to meet you!" which is absolutely why we love you and asked to interview you for the enthusiasm chapter! Where does that enthusiasm come from?*

LD: LIFE LIFE LIFE LIFE LIFE.
 Being born was pretty much THE BEST THING EVER.

TDOY: *Were you ever embarrassed by things that enthused you or by having an enthusiastic attitude? If so,* how did you eventually accept it, own it and show it to the world?

LD: Bahahahahahahahahahahahaha. OMG. No.
 When I was a teenager, I used to have random bouts of "OMG—I AM WEIRD! Why am I so weird? Why can't I just be normal?"
 But then I'd think about it and see that everyone being "normal" was kinda miserable, and I was already having the best time ever, so I should just keep doing what I'm doing.
 Whenever I get confused, I think: Whoever is happiest WINS.

And me being me—ridunkulously gigglesnorting, over-lisciously overexcitable, gloriously unkept ME—that's what makes me happy.

So I stick to it.

P.S. I think if I were a dog, I would be a Very Happy Labrador—one that jumped up and licked everyone's faces and thought every day was The Best Day Ever.

How can you NOT win if you're a Very Happy Labrador?

TDOY: *Does your enthusiasm fuel your business? In other words, do you decide on your next project(s) because that's where your enthusiasm lies at the time, or do other factors play a part?*

LD: Oh, gosh yes. It's where everything flows through. My blog posts, my creations, everything I share feels like it comes from that great source of enthusiasm and inspiration. I like that dude Dr. Dyer's take on it—inspired really means you are "in spirit."

There's nothing I love more than being in communion with Great Spirit, feeling like its dictation queen for messages of love and creativity.

TDOY: *As a writer, circle leader and artist, you've worked with thousands of women. In your opinion, what holds someone back from discovering her enthusiasm? And how can she start exploring to find it?*

LD: Fear. Thoughts that she can't do it. Conditioning. Because somewhere along the line, someone who was really, really confused told her that it wasn't good to be so excited and enthused and gloriously unkempt.

I just want to let you know that they were mistaken. They were confused. They didn't know the way, either.

And you have a chance, a choice, a path now where you can know the way.

Here's the secret:

Whatever lights you up is the way.

That's the only truth you need to know.

TDOY: *What's your personal declaration for enthusiasm?*

LD: DOOOOOOOOOOOOOOOOO EEEEEEEEEEEEEEEEEEEEEEEET.

Leonie Dawson is a writer, blogger, retreat leader, globe-trotter, visual artist, mama and vessel of wild creativity and cosmic prosperity for the 20,000 women who orbit around her virtual altar each month. Come swirl with her at www.leoniedawson.com.

ENTHUSIASM (make it!)
Big Likes Vision Board

Most people are probably familiar with the idea of collaging. The idea behind this exercise is, by having fun and tearing out words and images that resonate with you, you're actually tapping into your subconscious and getting to the root of what YOU like and desire. You may start to uncover themes and common threads that you didn't noticed before. Don't think too much about what you're tearing out! That's where the magic lies. So get your stack of magazines and tear out images that speak to you. Don't think too hard about it—tear away!

What You Need

- poster board (any size)
- magazines
- scissors
- rubber cement or glue stick

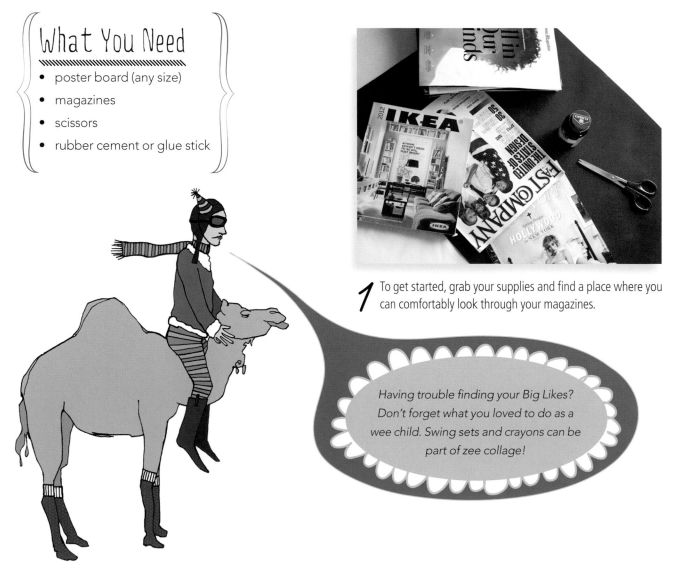

1 To get started, grab your supplies and find a place where you can comfortably look through your magazines.

Having trouble finding your Big Likes? Don't forget what you loved to do as a wee child. Swing sets and crayons can be part of zee collage!

2 Start cutting out words and images that resonate with your Big Likes. Don't think too hard; whatever you think is right is right!

3 Once you have a stack of words and images, start gluing them onto the poster board. Work intuitively and quickly. Don't be afraid to layer and overlap, because the point of the exercise is to get everything down onto the poster board, not to put it in the "right" spot. Making it imperfect will make it more dynamic (and more fun for you)!

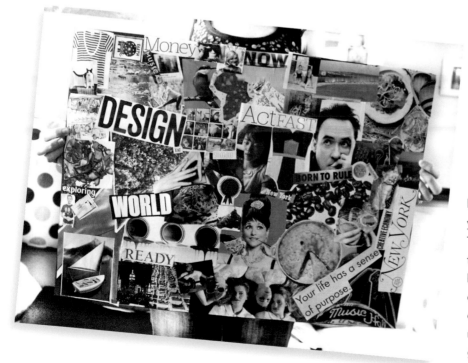

When you're done, step back and look at it from a few feet away. Do you notice any common threads? Themes? Colors? We did this one together and found our mutual love of healthy food, bright colors, travel and creativity. Maybe the next Declaration of You incarnation will be a Caribbean retreat with an organic chef? Sounds good to us!

To watch our ENTHUSIASM video, go to www.createmixedmedia.com/ thedeclarationofyou. (There's an audio version there, as well.)

UNIQUITY
(discover it)

Whether you're an artist launching a new Etsy shop or a writer looking for a full-time gig or simply a person looking for her spark, being authentic is what makes you *you* and what will set you apart. Some will call it "branding," but how boring is that? (And hello, what a way to bring on a case of the "shoulds!") Your uniquity is what makes you interesting. Your uniquity is what others will relate to. Your uniquity is what will get you the sales, the clients, or the job. Your uniquity is why people will want to work with *you*. Your uniquity *is* you; it's why you're awesome.

Michelle says—

The biggest thing I learned when I pounded the pavement as an actor was, well, what made me me—my uniquity, my spark, what made me different and where I thrived. From those post-college years, I learned that I loved (and got cast!) singing loud and funny; creating new, SNL-like characters; portraying multiple roles at once; and being quirky, enthusiastic, spunky and offbeat. Once I put those pieces together, the light-bulb went off over my head, and I made sure to bring my quirky, spunky, offbeat enthusiasm into the room the first time I entered, whether it was visually with a polka-dot dress (and matching headband) or audibly with the song I sang to show that I was both funny and loud! Allowing myself to be me let me be secure with bringing myself into the room and put me at ease almost instantly.

I've been able to bring that into my coaching practice and pair it with what I know makes me spark (writing, speaking, coaching, collaborating, relationship building). I'm able to see what is in line with my authenticity because I know what makes me, um, me.

But how do you find your uniquity? Some do it by making the big, fat mistake of comparing themselves to others who are doing similar things, which essentially lets the Comparison Vampire outta the coffin.

If you're anything like us, searching and clicking onto the websites of those who are doing what you're doing or what you *want* to be doing ends up being a one-way trip to Loser Land, with stops at She'sWayMoreTalentedThanMe City, ICanNeverBeAsSuccessfulAsSheIs Town, IfShe'sAlreadyDoingItWhyShouldI County and the big continent of What'sThePointAnyway. These are not fun places to visit, and yet some of us decide to live there!

How do you get a one-way ticket back from Loser Land? You don't need to click your heels three times. Instead, all you have to do is realize *IT'S A CHOICE!* You don't have to fall into the self-comparison trap! And yes, "it's a choice" needed to be capitalized, italicized and bolded for extra effect. We're learning that just because other people out there create and do things that we admire intensely does not mean for one second that we shouldn't also be making and doing things we're proud of.

Letting yourself play the comparison game, and then letting that game stop you from creating whatever it is that you know deep down you want to create, robs those people who are out there ready to admire and adore you and your unique brilliance.

People are amazing, aren't they? You could probably list twenty people right now who you think are just the coolest and most talented people on earth. But here's the thing: You're amazing, too. We're all amazing because we're complex, beautiful, unique and flawed human beings—all of us, just because we're alive. We read recently that only one in every ten billion living creatures on earth is a human. Isn't that astounding? One in ten billion! We're quite special.

It takes practice to be kind to ourselves. We hold all kinds of rules for ourselves and ideas about how we should be, and in reality we just picked them up along the way somewhere, thinking it was "the right way to do things," and now it's time to let them go. We need to be kinder to ourselves and listen to our own hearts; ask ourselves, "What do I want to do?" And then do that. Not according to how anyone else thinks you should do it, but however you want to do it, in a way that makes your heart sing and skip beats and jump up and down in your throat. Because why would you even want to compare when you feel that?

That's joy, people. Tapping into your purpose.

Our purpose as humans is to be happy and to love one another. That can only stem from first loving and valuing ourselves. And let's face it: We all have something unique to bring to the table. Even if your style of painting or photography or dancing is similar to someone else's (that's why broad categories like Pop Art and Modern Dance exist), it doesn't mean that it's a copy. It can't be. If you see a still life exhibit, does every bowl of fruit contain the same fruits in the same order, or is it shot or painted the same way with the same colors and the same style? Of course not. It's impossible, really.

So let's just do what we usually do anyway—checking out/sizing up/building up the competition—but INSTEAD use it to stop at Motivation Junction, Inspiration Land and Uniquity County. Those places are much prettier.

OK, so here's an exercise for you. First, think of three people who are doing what you strive to do. And no, these don't all have to be big shots like Oprah or SARK, but they can be your friend who's such a great mom or your own mom or your first boss who pulled out all the stops to teach, support and enthuse you. Got 'em? Good. Now write down the names of those three people in the spaces at the top of the Three Greats worksheet that follows. In the rows beneath the names, write down their attributes. If it's difficult to pick them out, ask yourself:

• What do I admire about so-and-so?

• Why do I think so-and-so is so awesome?

• If I had to write so-and-so a letter and explain why she's so inspiring, what would I say?

• Why am I attracted to this person (why do I always read her blog/buy her art/ask her to hang out)?

TOPIC: Three Greats

_____'s attributes	_____'s attributes	_____'s attributes

Now, let's sum it up. If you needed to write one sentence explaining what these three people have in common that rocks your socks right off, what would you say?

These three people rock my socks because
_____.

Here's where it gets scary: We're gonna focus on why YOU'RE awesome! Step out of your own shoes and into the shoes of someone whose socks you rock right off their feet. And don't tell us that there's nobody whose socks you rock. We don't buy it. Own it—it's OK!

Write this person's name down in the blank space at the top of the Whose Socks I Rock worksheet. If you want, get a picture of 'em and put it nearby for extra effect.

For extra, extra effect, ask 'em to fill this out for you! We know it's super scary, but you don't have to watch.

Can you begin to see that the three people you wrote down on the Three People worksheet are just different from you? Not better, not worse, just different and unique?

Consider that you each have an audience of people who will resonate with you, and your intention is to find those people. Look at the attributes of your three people next to what makes you unique. Spend some time seeing the lists as descriptions of completely different individuals. It's like comparing apples and oranges!

It's time to become the owner of those unique gems that are shining inside of you, and declare what makes you sparkle below!

UNIQUITY DECLARATION

I declare that, above all, I'm unique because _____

_____.

Whose Socks I Rock

admires me because...

thinks I'm awesome because...

I inspire because...

thanks me often for...

thinks I'm different because...

is attracted to me because...

And now the scariest of all. **I'M UNIQUE BECAUSE:**

Now let's pretend you're Person number 4! What are YOUR attributes?

YourNameHereLand

Think of who lives in YourNameHereLand. Danielle LaPorte calls it members of your tribe—people who see the world the same as you do, even though they probably have different personality traits or different skill sets. Who do you want in Your Tribe? On the YourNameHereLand worksheet, make a list of the twenty people who get a seat on the bus going there and why, by including a handful of ways to describe them.

When you're done, note the common themes. You'll soon see who's part of your community and the traits that new people need to get a seat on the next ride.

Kids Play

What did you like to do when you were a kid? We think that points directly to the work and play that you probably love to do as an adult! Use the Kids Play worksheet to make a list of all those things you loved to do that still get you jazzed. Also, if you used to love to color as a kid, but you haven't colored in thirty years, maybe that could be on the list, too. Who knows? Maybe you'll pick up a coloring book next time you're at Target!

Unique as Snowflakes

It's time to take stock of the sum of your unique parts! Use the I'm a Snowflake worksheet to get down what you do well (e.g., put together an outfit for $10), how you do it (e.g., with an undying thrift-store obsession), and why (e.g., I'd rather spend my money on trips to Europe!). Don't just take into account your own views on yourself, though. Send an e-mail to the friends and family who know you and love you almost unconditionally, ask them why they find you inspiring and promise to reciprocate. Yes, you feel kind of like an ass asking, but the great thing is that you respond to everyone who answers and tell them what makes them unique. Then the Snowflake Worksheet will show you that, sure, maybe thousands of people can put together a $10 outfit, but only you do it with a smile while playing the ukulele and giving great hugs!

You're Amazing!

Still need some space to jot down your thoughts? Go to www.createmixedmedia.com/thedeclarationofyou and find a downloadable worksheet for you to list all of the ways you're amazing!

TOPIC: YourNameHereLand

name of person on my bus	he/she got there because

KiDS PLAY

TOPIC: Kids Play

(what you loved to do as a child and still do)

i'M A Snowflake!

TOPIC: I'm a Snowflake!

What I Do:

How I Do It:

Why I Do It:

UNIQUITY (own it!)
Colleen Wainwright

● ● ● ● ● ● ● ● ● ● ● ● ● ● ●

But absolutely, I worried about how I would look (I have a big head! And a rather manly jaw!), as well as how I'd be perceived. Most people assume I'm ill, which I feel kind of bad about. And plenty of others assume I'm gay, which doesn't really bother me except for from a dating-availability perspective. (Although maybe I should embrace that it's doubling my prospects—hmm . . .)

It's amusing to be judged exotic, and it's been fascinating being visible again. Basically, I'm enjoying the experience of interacting with the world in a whole new way at fifty, more than I'm bothered by the idea of people creating stories about me being this or that. What a spectacular lesson in judgment this is proving!

At some point, my fascination may wane, and I'll grow back my hair. For now, it's useful as a writer to feel what it's like to be an outsider just by walking around. Although, I will miss the unparalleled ease of the buzz cut from a styling standpoint.

TDOY: *It's sometimes reeeeeeeally uncomfortable to not only discover—and articulate—what makes one unique, but to then own it and shout it from the rooftops! How have you been able to embrace that, and what would you suggest to others looking to do the same thing?*

CW: I wouldn't say that I have embraced it! Or even fully discovered it! And while I'm all for self-understanding and self-acceptance, shouting is optional. It's a point on the dial, and it's definitely not for everyone.

As to the actual excavation process, I don't think there's one path, and I don't think it's a straight line with a beginning and end point. Many things have helped me along the way—therapy, books, writing. Studying acting. Failure has

TDOY: *You shaved your head as a reward for raising $50,000 for WriteGirl in 50 days. (Amen and hallelujah!) Did you have any second thoughts as to how you'd look or how people would perceive you by going outside the norm of what's seen as "acceptable?"*

CW: Once I'd made the decision to go public with my intention to raise a ridiculous amount of money, most of my worries centered around being branded a failure, not a freak. Nothing is less flattering (or more motivating) than public humiliation on a grand scale.

been hugely illuminating at every step, as has an examination of what pisses me off. (Note: That which is the least fun is often the most helpful.)

Articulation is similarly iterative. You're changing all the time (we hope!), and so is your bio. While you have to do much of the work yourself, it can help to get an outside perspective. I went to the readers of my blog and asked them. It was a really helpful exercise.

If you don't have an audience you can ask, start paying attention to how people describe you. Notice how they introduce you to other people, what kinds of things they thank you for helping them with—that sort of thing. You'll find gold there.

TDOY: *You were an ad writer and actress who's now the Communicatrix, helping creatives "connect more effectively with the people who need to hear them." In your opinion, what does a creative person need to do in order to reach their people?*

CW: Assuming you're a creative person who is truly ready to reach her people—and too many of us jump the gun on this, myself included—I think you have to be very clear on who you serve and what you have to offer them. As we're flooded with more and more requests for our attention, clarity of message and focus become increasingly important.

But try not to chase. I truly believe you and the world are best served by putting your energy first and foremost into excellence, not messaging. If you create truly epic shit, don't worry—people will find you.

TDOY: *There's often a roadblock that we feel when it comes to flaunting what makes us unique, as we're afraid it's seen as braggy, spammy, or jerky. How can you ensure that these two things don't go hand-in-hand?*

CW: Don't spam! Or brag or be an ass!

If you are really and truly being yourself, acting out of service and with a need to fully express your human potential rather than to gain external validation or to hijack eyeballs, I don't think it is flaunting—it's just being.

You want to remain sensitive to the room, of course. There are places and situations where it's appropriate to dial the volume up or down. And it's always better to listen more than you talk.

TDOY: *What's your personal declaration for uniquity?*

CW: You are already unique. The sooner you get down with that, the sooner you can begin joyously interacting with other people. At least, that's what I'm hoping!

Colleen Wainwright is a writer-speaker-layout who started calling herself "the Communicatrix" (www.communicatrix.com) when she hit three hyphens. She spent ten years writing ads and another ten acting in them for cash money. Today she helps fellow creatives learn to talk about themselves in a way that wins them attention, work and satisfaction. In 2011, Colleen used herself as a guinea pig for her theories on social media marketing, raising more than $50,000 in fifty days for a nonprofit benefitting high-school girls. It was the highlight of her young life.

To watch an extended video interview with COLLEEN WAINWRIGHT, go to www.createmixedmedia.com/thedeclarationofyou. (There's an audio version there, as well.)

UNIQUITY (make it!)
Body Art

There's something powerful about seeing images and words that represent the things you love in life, so why not have some fun and draw them on your body to double the power?

Let your inner child out and draw all over yourself. We promise it's serious fun. Do it with your friends, your kids, your family—anyone who wants to represent who they are on their bodies without permanent ink and needles.

What You Need

- Caran d'Ache water-soluble crayons or face paint of some sort
- cup of water
- your body

1 Dip a crayon into the cup of water. Begin drawing on your body wherever you please. Draw things you love and write words that are meaningful to you—the more, the better! Use as many colors as you'd like. Once you're finished, take a photo so you can look back at it and remember what makes you YOU!

Look at me in my scuba outfit riding my kangaroo, Amélie. If I am not unique, nobody is unique.

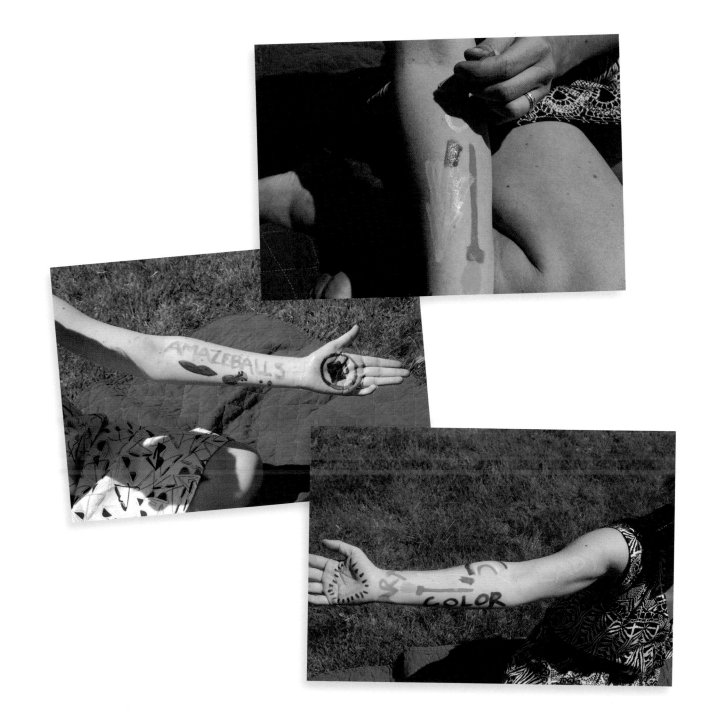

To watch our UNIQUITY video, go to www.createmixedmedia.com/thedeclarationofyou. (There's an audio version there, as well.)

DECLARATION 3

intention

INTENTION
(discover it)

The word *intention* used to make us sort of nervous. We felt like if we were going to set an intention, it had to be a *really* good one. It needed to be serious and deep and life changing. It needed to MEAN SOMETHING. So, as you can imagine, neither of us set many intentions. It's the same with prayer. A prayer couldn't be anything frivolous; prayers are supposed to be religious and transformational and profound. That's a lot of pressure, yes?

So slowly we've adopted a slightly different way of thinking about it, and we've asked ourselves this question: What happens if we allow intentions and prayers to be lighthearted and joyful? What if they don't always have to be so serious?

You can set an intention before a phone call to be calm and clear. You can set an intention before dinner to eat more slowly. To wake up earlier. To look for things to laugh about. To compliment people on their outfits. You can set an intention to be open to new possibilities. You can set hundreds of intentions a day if you want to!

Setting intentions is a way to point yourself in the direction of what you want in your life. And that can be fun! One of our favorite ways to practice intentions is to write this phrase at the top of a to-do list each morning:

I am willing to _____.

In saying that we allow ourselves to be *willing* to do or feel something, it softens it a little bit. It's different than an affirmation. Affirmations are tricky because it's almost like you're tricking yourself into believing something that you don't believe yet.

For example, if you want to make $100,000 a year in your creative business, you would use an affirmation such as, "I am making $100,000 a year," like it's already happening. But it's hard to BELIEVE it when it's clearly NOT happening yet. And that's not gonna do squat. But conversely, let's say you want to make $100,000 a year, and you write, "I am willing to believe that I am capable of making $100,000 a year in my creative business." There's an opening there.

It's much more gentle, yes? It leaves room to grow into the intention, even if you don't quite believe it yet. You're just intending to be willing! And that intention will get you there. By being willing, you're opening yourself to new possibilities. By saying you're *willing*, you allow your imagination and your heart to take over and let your thinking brain take a back seat.

Let's try it. On the Things I Want to Receive worksheet, list some things that you want to receive in your life or some ways that you want to feel, and don't forget the fun, little things! Also, notice how we used the word *receive* instead of the words *achieve* or *get*? Take a minute to sit with each of those words and notice how they make you feel.

Our guess is that *receive* automatically makes you feel a bit more open, relaxed and at ease. *Achieve* and *get* are all about action and "making it happen." Force. Sheer will. Using the word *receive* is a little gentler. Expansive.

Relaxing. It reminds us that attaining the things we desire doesn't have to be so *hard*! There's a subtle difference, too: When you're trying to achieve something, you're reaching for something that doesn't exist yet. You don't know if it's going to happen, even though you're trying really hard. When you set out to receive something instead of achieve it, it's like you're telling the universe that you believe it's already in existence, on its way to you right now.

Now, your job is to open yourself up to the signals that will move you in that direction and then to take those steps when they present themselves. You still have to be an active member of the dream making, but you can relax a little more about it. Nice, right? Right. If the word *receive* doesn't give you that feeling, cross it out and use a word that resonates with you. Don't worry. We won't take it personally. In fact, we encourage it.

Using the Things I Want to Receive worksheet, list some things in the left column that you want to receive and/or ways you want to feel. Now, in the right column, turn that into an intention, starting with the phrase "I am willing to . . . " For example, if one of the things I want to feel—"To be peaceful"—is in the left column, the right column might say, "I am willing to take deep breaths" and/or "I am willing to recognize and honor my limits."

TOPIC: Things I Want to Receive

things I want to recieve/ way I want to feel	I am willing to...

Although we can't determine *exactly* how our lives will turn out, we can decide how we want to go into every situation; process the information we're given; and respond in a way that correlates to our ideals, values and uniquity. That's what intentions are all about—making the choice about how we lead our lives. Pretty powerful stuff, huh? We think so, too.

Because *The Declaration of You* is about the Bigger Picture, we're going to pinpoint a big, general intention that you wanna bring into your life above the other intentions. Please, please, please (with whipped cream, nuts, sprinkles and a cherry on top) don't think that you're stuck with this intention in any way, shape or form. You're at absolute liberty to change your intention at any point in time 'cause that's the beauty of intentions! You can also revisit this exercise at any time if you feel that the intention you declared isn't The Big One any longer.

That said, let's get down on a worksheet the things that you're struggling with now. What's been challenging you for a while? List these things in the left column of the Ways I'm Being Challenged worksheet, while using the right column to write down the intentions that could help you overcome the challenge. Here's an example:

I'M BEING CHALLENGED BY: not finding time to exercise. THE INTENTION(S) THAT CAN HELP ARE: health and wellness, self-care, making it fun.

You see the declaration looming closer, don't you? That's because we're almost there! Look at what you wrote in the second column along with the first list of things you want to receive or feel from the Things I Want to Receive worksheet, and decide which intention is the most important or helpful to you. That's the intention to use in the blank below—your Big Intention!

INTENTION DECLARATION

I declare that I want to intend _____

_____.

TOPIC: Ways I'm Being Challenged

I'm being challenged by...	The intention(s) that can help are...

extra extra!

One-Word Intention

Set one word as your intention for this month, and write it at the top of the One-Word Intention worksheet. Start right now! How do you want to feel? Is there something you want to receive? Pair that with five simple ways you can practice that intention. For example, you can simply practice the intention of "breathing" by taking a moment for yourself between tasks; going with the current; giving yourself permission to walk away from what's not working; listening to your body; and experiencing the present.

Once you have those down, think of activities that go along with that intention. For "breathing," you can put down meditation, yoga and power naps. For, say, "enthusiasm," you might put down sporting events and concerts. See where this is going? Now, don't think you have to do everything on your activities list, but what a great way to try new things that have a similar theme and structure your life around your intention!

Your Mission

Discover your mission statement! FranklinCovey has a great interactive one at www.franklincovey.com/msb that you can e-mail to yourself so you can look at it often. If that's too boring, pour yourself your favorite beverage and enjoy some John Legend (yes, you're wooing yourself here), and ask what you uniquely bring to the table, why you're awesome, what you don't tolerate, what your trademark is, what you want to be remembered for and what you want to do above all. When you're done, go back over it and highlight the statements that empower you. Try to limit it to ten statements. Start a fresh page and write (or draw, doodle or collage) those statements into their own work. Then put it on your bulletin board or on the inside of your closet (not everyone has to see!) so it'll give you a boost and some direction each and every day!

TOPIC: One-Word Intention

Intention for the month:

Simple ways to practice this intention:

Actions/activities that could support this intention:

Word of the Year

We love the idea of creating an overarching theme for your year. Don't confine yourself to the dates of the calendar (e.g., starting on January 1st); you can start at any time! Just pick a day and pick your theme. Think about how you want to take care of yourself during the year or how you want to approach your day-to-day life. How do you want to feel? What sort of attitude do you want to have? What do you want to bring forth in your life? If you're stuck, do a quick brain-dump of the words in your head—no censoring—and see what resonates the most. You can also plug those words into thesaurus.com and see what other words might hit closer to home for you.

Pick the word that feels right, write it on the My Word of the Year worksheet, and also jot down some thoughts about why you chose the words you did. Look at it often to remind yourself to live your intention every day!

Stuck on your intentions? Remember to start with zee words, "I'm willing" and then write down zee first thing that comes into your pretty head.

MY WORD OF THE YEAR IS:

My word of the year is...

AND WHY:

...And why...

INTENTION (own it!)
Andrea Scher

They calibrated my sense of what was possible, and they helped me access my subconscious. They helped illuminate my dreams that lived just under the surface and where I was going creatively, professionally, spiritually, etc.

I began inviting my blog readers to post their lists as well, every New Year, and the idea caught on like wildfire. When I dreamed of creating an online course, Mondo Beyondo seemed like the juiciest topic. What happens after you make your list? What does it take to make big dreams come true? How do you even know what your dreams are? This is what Jen Lemen and I explore in our e-course.

TDOY: *Do you set intentions? If so, how often, and how do you determine what the intention needs to be?*

AS: I don't set specific intentions, but in true Mondo Beyondo form, I make lists of outrageous things I would love to have happen in my life. It sets the bar of what's possible much higher than if I was simply writing a list of goals. The Mondo Beyondo list stretches you to move into more vulnerable realms—deeper unspoken dreams, things we don't know how to achieve, things we long for but would never say out loud. It also paves the way for serendipity and magic.

After writing for ten minutes or so, I read my list and begin to see themes crop up. Certain threads begin to reveal themselves, and I can see more clearly what's next for me to manifest. For example, if there's a lot of money stuff on my list, I can see that it's time to focus on *abundance*. If a lot of travel, workshops, and/or time with friends is on my list, I can see that it is a time for *retreat*, for adventure and for filling the creative well. This can help guide me in my intentions, align with my heart and listen to my intuition.

TDOY: *You're the co-creator of Mondo Beyondo, a wildly successful e-course that promises to "help you take your dreams from the realm of wishing into everyday motion." What was the impetus for creating Mondo Beyondo?*

AS: The original idea came from a friend of mine who, when she set out goals with her husband each year, always did a "Mondo Beyondo" list as well. This was a list of the most outrageously wonderful things she could imagine happening that year—like meeting Bruce Springsteen or renting a villa in Tuscany for the summer. When I heard those words, it was like a neon sign in my mind. I realized what had been missing from my dreaming life; I hadn't really ventured into the realm of the impossible. I had always played it safe and had never dreamt big.

I started making Mondo Beyondo lists every New Year's Day and realized that they did two really important things:

TDOY: *Have you had experiences where you believe that an outcome was the direct relation to setting an intention? A Law of Attraction experience, if you see it that way?*

AS: I live for Law of Attraction–type experiences! I have had many. Some of the more notable ones in my life involved meeting people I greatly admired, my personal heroes.

Here's one: One day, while I was working in a clothing store in San Francisco, I got into a conversation with a customer about the musician Ben Harper. I told him, "There are artists you love, and there are artists you'd like to meet. I'd like to meet Ben Harper." Two hours later, when my shift was over, I started walking back home but stopped in my tracks. "*Why are you walking home so soon?*" a voice inside me said. "*It's a beautiful day! Take a walk and catch the bus if you get tired.*"

I started walking in the opposite direction of my home, enjoying the sunshine and the city. When I did eventually get tired, I hopped on the Fillmore 22 and sat down right next to, you guessed it, Ben Harper. Ben freaking Harper! I tapped him on the shoulder (while my heart pounded inside my chest) and asked if his name was Ben. When he nodded yes, I said, "I can't believe how quickly the universe works. I just said I wanted to meet you two hours ago."

I am always on the lookout for what I call *clues*—little signposts pointing me in the right direction; a fortune cookie message that says just what you needed to hear; the old friend who pops into your mind and suddenly she calls; the sudden urge to have a salted caramel and someone offers you one at the cafe. These little bits of magic remind me that I am held in a mystery much larger than myself. They show me that I am not alone; that the Universe is working with me on making my dreams come true.

TDOY: *What have you found happens to your Mondo Beyondo students once they articulate and acknowledge their big dreams?*

AS: I think initially, there is pure glee and giddiness about the possibility that they have just declared. I think it's extremely energizing to say, *I want this!* It also requires a certain amount of courage and vulnerability, because fear can

kick in pretty quickly as well. The inner critics are right there ready to pounce—*Fat chance, even if you wrote that book, who would buy it? Don't you think other people have tried this? How do you think you're going to fund this big dream? And by the way, who do you think you are?*

These are such mean voices! They seem to live just below the surface, ready to rear their heads when we are willing to be brave and vulnerable. This is why having support is so crucial to any dreaming process. After the high of dreaming, we are bound to crash, and this is where we need cheerleaders who won't let us quit, coaches and friends who remind us of our greatness, and a clear vision of who we are and what we value so those ideals can guide us.

Those critical voices are powerful, but they don't stand a chance when you are fierce in your commitment and you stay true to your vision. But we can't do it alone. We need each other.

TDOY: *What's your personal declaration for intention?*

AS: I believe that my intentions are a powerful declaration both to myself and to the Universe. Speaking them out loud (to myself or to someone else) sets something in motion, a kind of wave of energy that I have to be ready to ride. It will usually require something of me: courage and a willingness to be vulnerable. If my intentions are aligned with my spirit, however, this momentum can only take me to new places of growth, joy, and fulfillment. I trust my intentions to carry me exactly where I need to go.

Andrea Scher is an artist, writer and big believer in the transformative power of creativity. Through her e-courses Superhero Photo and Mondo Beyondo, Andrea inspires us all to live authentic, colorful and creative lives. Best known as the author of the award-winning blog Superhero Journal, her writing and photography have been featured in books and magazines around the world. Andrea currently lives in Berkeley with her husband and two sons. You can find her at www.superherolife.com.

INTENTION (make it!)
Dear Future Me Letter

The idea behind the Dear Future Me Letter is to imagine your life one year from today and then write down all the goodness that happened to you in that year. It's a place to describe, in detail, the way you envision the next year—from this moment forward—unfolding. Start the letter by writing today's date, but one year from now (e.g., if today is September 14, 2014, your letter will be dated September 14, 2015).

Imagine everything you want to have happen in your life from now until then, and write it as if it already occurred! There are no right or wrong things to talk about, but you might want to mention the goals you reached, the new activities you tried, the place(s) you traveled, the new friends you made, the career successes you achieved, and even how you look and feel.

When you're done with the letter, insert it into the envelope and seal that puppy up with tape or a cute sticker. You're not going to look at this letter again until next year, so please don't put any pressure on yourself to find a way to start making all these amazing things happen in your life. The idea is to envision your ideal life, write it down, put it out into the universe, and then let it go. The letting go is where the magic will happen! Seal up the letter and then forget about it, and trust that putting it out there is enough!

If you want some examples, Michelle is crazy and posts her annual Dear Future Me letters on her blog. Jess Lively of Makeunder Your Life (who we totally stole this idea from) also talks about her Dear Future Me letter (and how more than 80 percent of the stuff she wrote down actually happened!) on her site. Isn't that the coolest thing ever? You can find a link for Jess' site and a download of Michelle's letters at www.createmixedmedia.com/thedeclarationofyou.

What You Need

- 8.5" x 11" (22cm x 28cm) paper
- scissors
- glue or rubber cement
- magazines
- ruler
- pencil

1 Begin with a plain sheet of paper. Measure ½" (13mm) from both long sides of the page and draw a line with your pencil

2 Fold in both edges along the line.

3 Measure 4" (10cm) from the bottom of the page width-wise and draw a line with your pencil. Fold on the line. This will form the pocket of your envelope.

4 Fold down the remaining top edge.

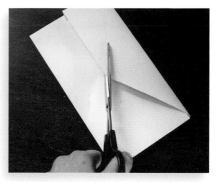

5 Measure halfway across the top flap and make a small mark with your pencil. Cut diagonally from the pencil mark to the folded edge. Repeat on the other side. The top will be a triangular shape.

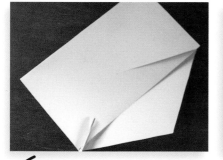

6 Measure to the center of the pocket and make a mark 2" (5cm) down. Cut from the top edge of the pocket to that pencil mark. Repeat on the other side.

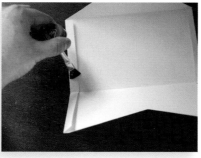

7 Glue the folded edges together on each side.

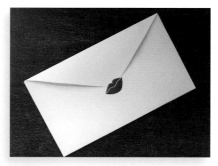

8 You now have a finished envelope—congratulations!

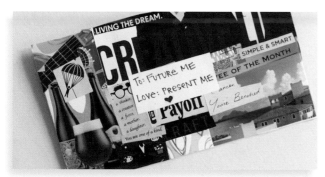

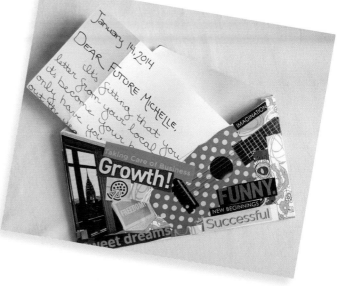

9 Now, if you like, you can have fun embellishing the envelope. We've collaged this one, but feel free to draw, color, cover it in stickers, use glitter, or do whatever floats your boat in making your Dear Future Me holder exciting and enticing.

To watch our INTENTION video, go to www.createmixedmedia.com/thedeclarationofyou. (There's an audio version there, as well.)

DECLARATION 4

SELF-CARE

SELF-CARE
(discover it)

If you're anything like us, you wear many hats. There's probably the Creative hat, the "Insert-Day-Job-Here" hat, maybe the Spousal hat, the Daughter hat, the Great Friend hat, possibly the Party hat . . . need we go on? OK. But do you ever think about the *Me* hat? Have you seen that hat lying around lately? (For a fun little project to help you identify all the different roles you play in your life, go to www.createmixedmedia.com/thedeclarationofyou to download All the Hats I Wear.)

Michelle says—

There have been points in my life where I didn't even really know what the Me hat looked like, because my personality shifted with each hat I donned. Sometimes I'd wear the Trash Talker hat, or I'd focus on the Responsible Adult hat; sometimes I'd lose the Sense of Humor hat. (My own mom admitted that she didn't think I was funny when I was in college, and I had all my friends call her to leave testaments to my funniness.)

It wasn't until I realized I was spending time with everyone but myself (and not only was my energy level paying a price, but my identity was, too), that I discovered I had to stop being a people pleaser by learning to say "no" and scheduling time by myself for myself.

But making time for yourself is harder than it seems like it should be, right? I know! I'm a (recovering) master of not allowing myself to pamper, uh, myself.

Jess says—

*What gets in the way of you taking care of yourself? My excuse is always, "But I take **good enough** care of myself . . . I have too much work to do, to do anything extra to pamper myself." WHAT??!? This is crazy talk. I'm sure you have your own version of this excuse (or maybe even multiple excuses!). The world will surely collapse if you take time out for yourself, right?*

WRONG.

I know I'm not taking good enough care of myself when I'm feeling drained of ideas and inspiration, and I don't want to work on anything—all I want to do is sleep. Or, on the flip side, when I'm unable to focus on work because I'm thinking about something I really want to do but am not letting myself, it's like an itch that needs to be scratched.

For example, when springtime rolled around, I had a serious craving for margaritas and Mexican food. It was a Tuesday, and I had a large amount of work to do. What do you think won the battle? You're right: the work. Until the next day. I couldn't handle it anymore. I dragged my husband out for Mexican food and margaritas in the springtime sunshine. And guess what? The world didn't fall apart! The work was still there when I got back, AND I was able to focus the next day because I listened to what my body and mind clearly wanted and scratched that itch.

So, what are you not allowing yourself to do? What do you LOVE to do for yourself, but you just don't ever do it because there's always something else that's "more important?" That stops now!

On the Ways I Take Care of Myself worksheet, list the ways you love to take care of yourself when you let yourself. Nothing is too silly! Maybe you love to go to a coffee shop with a newspaper by yourself on Saturday mornings, or you love bubble baths with a glass of wine and an iPod; maybe you like some sort of food that's on the expensive side (like fancy olives). Whatever it is, write it down!

Now, the next step is . . . you guessed it: You're going to actually DO those things you recorded on the worksheet. Yep! And you're gonna do one of them today—before you go to bed. We know you can find twenty minutes for yourself today, even if it means DVR-ing your favorite show or leaving your book club meeting early. To make sure you don't forget, right now pick the one self-care task you wanna do today and write it below. We'll wait.

Are we still waiting? No? Great! Now, put it into your calendar or your to-do list or a phone alarm to make sure you don't go to bed without doing it.

We know the excuses that might be going through your head. They probably sound like, "But there's really no time!" or "But I have so many responsibilities!" or "But that's so self-indulgent!" We want to encourage you to put those voices aside for today. You don't have to make this commitment every day for the rest of your days—you just have to think about today. If you're struggling to really find the time, think of the ways you procrastinate or waste time.

Do you find yourself saying, "That hour on Facebook was so unproductive" or "I don't know why I watched that TV show, I don't even like it!" Those are the things that you can replace with fulfilling self-care, even for "just" 20 minutes.

Once you've mastered taking it day by day, try a weekly pledge to devote X amount of time to self-care, with X being the amount of time that's realistic for you, even if it's "only" thirty minutes. Think of the one thing you want to do that's just for your happiness and peace of mind. Write that one thing down in your calendar, and don't move it! If you don't make yourself a priority, who else will?

Eliminating things from your life that you don't want to do is another great way to free up time for things you DO want to do. So, on the Self-Care worksheet, write down everything you want to remove from your life. From "not putting myself first (or second or third or fourth)" to "that positivity-sucking friend" or "watching *Jersey Shore*." Then, take a black marker and cross out everything you want to eliminate as a way to set the intention you're going to remove it. (It'll feel so good!)

Finally, use the Positivity List worksheet to compile things such as My Proudest Accomplishments or Things That Make Me Happy or Reasons to Celebrate. Or any number of other things. Just start it!

Now that you have a clearer sense of what you need more of (and less of) in your life, take a stand and make your Self-Care Declaration. You deserve it!

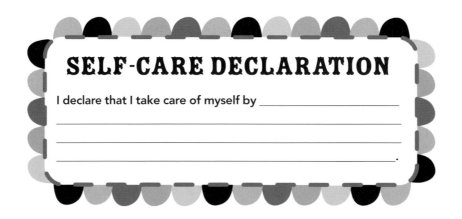

SELF-CARE DECLARATION

I declare that I take care of myself by _____

_____.

Ways I Take Care of Myself

These are the ways...

TOPIC: Self-Care

Things I Want to Eliminate:

TOPIC: Positivity List

My proudest accomplishments/Things that make me happy/ Reasons to celebrate:

Warm Fuzzies Folder

Start a Warm Fuzzies folder on your computer or in a note-book. When someone gives you a kind word or a compli-ment, print it out and put it in a folder or a scrapbook. If someone says it audibly, write it down when you get home or keep a notebook in your purse or pocket to write in.

Michelle says—

I have a Good Stuff folder in Evernote that I use, and saving it is as easy as highlighting the text I want to include, clicking the Evernote button, and choosing Good Stuff in the dropdown. If I get down on myself and think, "What have I done lately? Nothing, that's what!" I go to the Good Stuff folder and see how I'm oh-so-wrong.

Jess says—

I have a Warm Fuzzies folder within my e-mail where I store and save all the wonderful e-mails that I get, so I can look at them when I'm feeling discouraged or need a bit of lifting up!

My Alter Ego

Discover your inner parent/ass-kicker whose sole purpose is to make sure you're treating yourself nicely. Think of what he or she looks like, how he or she sounds, and what his or her name is. Now draw this disciplinarian, and write his or her bio or mission statement. For example, if you know you need a voice within you that will help you take things less seriously and will make your work more fun, you'd create Fiona, who has purple hair and writes in crayon and loves karaoke. She'll take care of that Vampire of Despair right good. We don't care if you're not an artist. In fact, we're pretty sure regardless of how you draw this person, it'll feel pretty liberating. (You don't have to be good at everything, you know.) You think you're a bad writer and can't write an eloquent bio? Who cares! Have a good time with it and don't judge it. Just do it!

Are you having trouble really believing that you can take time out for yourself? Start with just fifteen minutes a day and see what happens. You'll like it!

My ALTER EGO:

(dRAW HER/HIM!)

‹‹‹‹‹‹‹‹‹‹‹‹

(draw Her/Him!)

MY ALTER EGO

DESCRIPTION:
››››››››››››

Description:

SELF-CARE (own it!)
Jonathan Fields

TDOY: *You decided to leave lawyering behind when you once spent seventy-two hours straight working to meet a deadline, which was followed immediately by emergency surgery to repair a "softball-size infection" that was eating through your intestines. (Gulp.) While we're sure that was quite a wake-up call in and of itself, how did you really flip the switch to quit your job at an elite firm and commit yourself to doing what you love?*

JF: I made a list of the things I'd love to do if I could figure out how to make enough money to live well. Then I started asking different questions. Instead of "How can I justify leaving everything I've accomplished—the job so many others want, the time and money it took to get there," I asked, "How can I justify limiting the next forty to fifty years of work by what's happened in the last seven or eight?"

Learning to ask different questions—ones that allow you to create different stories—stories that enable rather than paralyze—was a critical piece of the reframe and of my ability to act.

TDOY: *You mentioned in your book, Career Renegade, that you got certified as a personal trainer while you were still studying law. How were you able to do that without your head exploding?*

JF: I've had a lifelong passion for the human body, kinesiology and movement, and I was a competitive gymnast for the better part of my early life. So I'd already developed a strong understanding of the body, both intuitively and academically. (I'm the dork with a functional anatomy textbook at the beach.) This gave me a really strong foundation to draw upon.

But, truth is, I'm pretty sure that, at some point, my head did come pretty close to exploding. At that time though, it was the thing I couldn't *not* do—so I did it. One of the great gifts of practicing law at a big firm in NYC is that I learned we're capable of accomplishing so much if we'd just stop wondering and complaining, and start doing.

TDOY: *According to your website, you're "A dad, husband, New Yorker, author and speaker, serial wellness-industry entrepreneur, recovering S.E.C./mega-firm hedge-fund lawyer, slightly warped, unusually stretchy, spiritually inclined, obsessed with creation, marketing and innovation consultant, venture partner and book-marketing educator." How do you balance it all? (If you do indeed feel that you balance it all?)*

JF: I don't. No such thing as balance when you strive for fully engaged living and work that comes from a place of passion and deep interest. That fuels you to want to go all-in on pretty much everything you do—often at the same time. Which is where the problem arises. You can't go all-in at all things, all the time. If you try, everything implodes.

So you've got to set up circuit breakers—planned vehicles that force you to step outside the creative process/venture and ask whether the way you're allocating your energy is aligned with who and what you hold dear in life. Find people to hold you accountable to this question on a regular basis, and if you find a disconnect in your energy and your values, adjust course, or at least acknowledge that things are out of whack. Then make a deliberate decision about how long you're willing to keep them there, why, and how you'll swing the energy pendulum back. This is what you sometimes have to do when you're launching a new endeavor. Choose consciously.

TDOY: *What does your self-care routine consist of?*

JF: Daily mindfulness, meditation and movement. Eating clean. Playing with my wife and daughter—a lot. Scheduling time to remove myself from work and create space.

TDOY: *What's your personal declaration for self-care?*

JF: Don't just plan, do!

Jonathan Fields is a dad, husband, author, speaker and serial wellness-industry entrepreneur. His latest book, *Uncertainty: Turning Fear and Doubt into Fuel for Brilliance,* was named the number one personal development book of 2011 by 800-CEO-Read. His first book, *Career Renegade,* was named a Top 10 Small Business Book by Small Business Trends. Fields writes on the crossroads of entrepreneurship, innovation and life at JonathanFields.com, explores life well-lived with acclaimed entrepreneurs, artists and authors on his Good Life Project web show (GoodLifeProject.com), and runs the book-marketing, educational venture Tribal Author (TribalAuthor.com). He's been featured in *The New York Times, Wall Street Journal, FastCompany, Inc., Entrepreneur, Forbes, USA Today,* CNBC, CNN.com, *Elle, Self, Fitness,* and thousands of other websites that sound cool but don't impress his daughter all that much.

To watch an extended video interview with JONATHAN FIELDS, go to www.createmixedmedia.com/thedeclarationofyou. (There's an audio version there, as well.)

SELF-CARE (own it!)
Natalia KW

was able to say goodbye to chronic migraines from cutting out dairy and to heal from chronic *candida* by boosting my immune system with raw-food nourishment. I stopped catching colds and mystery viruses that used to always hit me hard. I looked better, my skin cleared up, and my eyes brightened. But on a much deeper level, I experienced a profound shift in my emotional and spiritual state. I shed layers of my former self and emerged lighter, brighter and more focused than ever before. Things started to manifest before my eyes, and it was easy to make huge changes in my life that seemed impossible before. I began to lose interest in my "favorite" numbing activities like watching hours of television, playing video games and shopping at the mall. Instead, I was called to dance, to practice yoga and meditate, to be closer to nature and to spend more time with other people on a similar path. It was this part of the transformation that helped me to realign with my purpose and to truly live it every single day.

TDOY: *What's your favorite way to nourish yourself?*

NKW: My favorite way to nourish myself is to prepare a vibrant raw meal, from appetizers to dessert, and share it with my sweet husband and our family or friends, preferably outdoors. Pure food made with love + supportive community + being on the earth = my ideal nourishment.

TDOY: *You are a raw-food chef, author, and coach on a mission to help people "cultivate awareness of the foods that truly serve well-being in both body and soul." Can you tell us a bit about how changing your diet and the way you interact with food has transformed your life and your health?*

NKW: Changing my diet and the way I interact with food has transformed every facet of my being. On the surface, I

TDOY: *Can you share with us some of the ways you're mentally and emotionally kind to yourself?*

NKW: Being kind to myself is the only way I can truly stay on my path and be of service to others. On a good day (when I'm experiencing a normal level of work within my business), I wake up without an alarm, meditate and make a green juice or green smoothie before I get to work. These are absolute gifts that I wasn't able to make time for when

I worked for someone else, and I embrace these moments deeply. On a busy day, it may be that I pick only one of these, but it's non-negotiable that I allow myself at least one. Almost every weekday evening, I'll attend a yoga class to physically move any of the stress that's built up throughout the day. I feel my emotions, especially stress, in a very physical way, and yoga has become a necessity for me to stay balanced. When I've allowed stress or anxiety to build too much, discharging that energy through my bare feet on the earth is my ultimate reset button.

In a really sweet way, being kind to myself is also about celebrating my successes and new projects, and allowing myself space and time when things need to slow down. It's using the word "no" when something is out of alignment, even if that means giving an answer that I know the other person doesn't want to hear. It's shutting my computer down to run outside when the sun has come out after a month of rain, even when I'm on a deadline, because I can't afford not to.

Ultimately, being kind to myself is living with a deep sense of trust. It's pushing fear and pain aside and coming back to the reminder that it always works out beautifully in the end, always.

TDOY: *You believe in a pleasure-filled lifestyle (filled with delicious and nourishing food!). Can you give us some tips on how to bring more joy and pleasure into our everyday lives?*

NKW: Mmm, yes, I have such a passion for redefining pleasure. We can look at the surface of pleasure and see it as a fleeting moment of bliss, but I like to teach what I call "the full circle of pleasure." This means that we choose foods and experiences that bring us that instant, in-the-moment ecstasy, as well the lasting nourishment and healing that unfolds over time. So in everyday terms, this is choosing a

divine raw chocolate dessert over a donut, meeting both our emotional and physical needs without compromising our health. This also means choosing to spend time with people who really lift us up and support us. Sometimes this brings us to a career change to truly align us with our soul's purpose. Being able to make these changes is about connecting with our essence every single day; consciously listening to what our body and soul need and acting on those longings immediately—never waiting until tomorrow.

TDOY: *What is your personal declaration for self-care?*

NKW: I can only fully step up and be of service to my people and my planet while first caring for myself. Taking exquisite care of myself is not optional, nor is it something I will put off until tomorrow. As we care for and nourish all parts of ourselves—body, mind and sprit—life is more beautiful, more blissful and flows with more ease and grace.

Natalia KW is a pure-food chef, author, and shamanic practitioner combining the healing powers of both food and energy medicine to activate your highest potential in body, mind and spirit. The foundation of Natalia's work is conscious nourishment—helping her clients to cultivate awareness of the foods and experiences that enrich their well-being in both body and soul.

She is the author of three cookbooks: *Pure Pleasures, Cupcake Heaven and Raw Food Juice Bar*, filled with satisfying and sustainable-living food recipes. Natalia is also the co-founder of Nourishing Our Radiance, a community created to inspire women to transform their relationship to nourishment through compassionate mind-body awareness, luscious living foods and restorative self-care. Connect with Natalia at NataliaKW.com.

To watch an extended video interview with NATALIA KW, go to www.createmixedmedia.com/thedeclarationofyou. (There's an audio version there, as well.)

SELF-CARE (make it!)
Care Squares

● ● ● ● ● ● ● ● ● ● ● ●

The idea here is to create a visual reminder to make time for your self-care. These squares can be taped to your computer monitor. The computer is usually the culprit behind the excuse that we have too much to do, and we don't want the computer to win! You can also put these reminders on your television, mirrors, fridge or any other place that you feel you need it.

What You Need

- solid colored cardstock
- patterned paper
- scissors
- glue or rubber cement
- markers
- popsicle stick(s)
- clear tape

1 To get started, cut the patterned paper to any shape you'd like. You want the size to be big enough that you notice it, but not too big or else it won't stay up when you tape it.

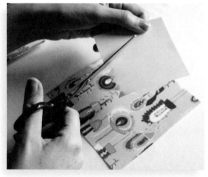

2 Then, from the cardstock, cut a shape that's a bit smaller than the patterned shape.

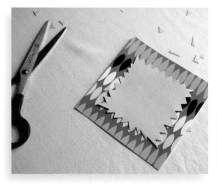

3 Glue the cardstock shape to the patterned paper.

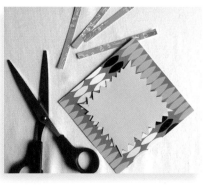

4 To spruce things up, you can cut thin strips of a third kind of paper to create a fancy border, if you like.

5 Glue these strips around the cardstock shape to frame it.

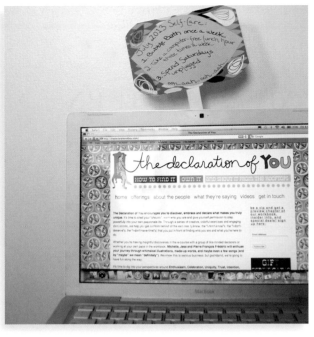

6 Now you're ready to write your friendly self-care reminders! If you're stuck as to what to write, the Ways I Take Care of Myself worksheet (the first one in this chapter) might be a good place to start.

Embellish however you please with stickers, glitter, markers, etc. The sky's the limit!

7 Once you're finished, glue your popsicle stick to the back of the self-care square and tape it to your computer. Now you'll never forget your Me Time!

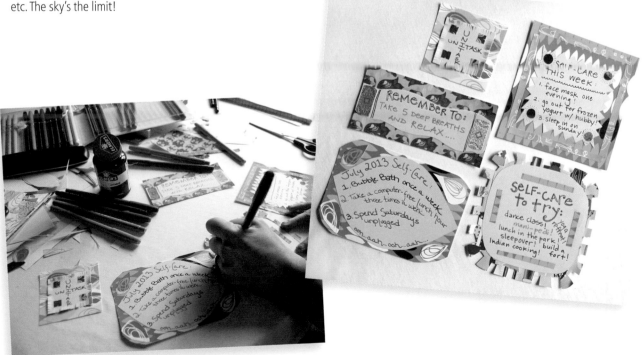

To watch our SELF-CARE video, go to www.createmixedmedia.com/thedeclarationofyou. (There's an audio version there, as well.)

SUCCESS
(discover it)

● ●

If we asked you about your definition of success in less than a handful of words, you'd probably say something along the lines of "stability" or "wealth" or "provider" or "hard work" or "responsibility." But have you ever stopped to think about whose answer you're spouting? Where did this definition come from? How did it get shaped?

In case you couldn't guess, this chapter is all about discovering what success means to *you*—not your sibling, your husband, or yo mama. Remember to keep that Judgment Vampire at bay while you work through this! We think the easiest way to focus on what success means to you personally is to get hooked on a feeling (and high on believing . . . that you're in love with meeeeeeeee! Sorry, that was an *Ally McBeal* aside).

Do us a favor and close your eyes right now. Oh, wait. Not *right now*, right now; we have to tell you why first. In a moment, set a timer for five minutes, get yourself in a comfy position (yes, lying down on a couch or the floor is acceptable, just don't fall asleep on us), and then let yourself drift to YourNameHereLand. Yep, this is an entire world that you create from scratch, where you can absolutely suspend reality. Could YourNameHereLand consist of money trees? Absolutely. What about blue ducks? Uh-huh.

And teleportation so you never have to commute again? Yes and yes. OK, *now* set the timer, lie down, and let your mind wander into YourNameHereLand. Ahhhh . . . If you need some help or want some expert guidance, allow Simeone Seol of House of HipGnosis to take you there. She created a meditation for this specific purpose, and you can find a link to download it at www.createmixedmedia. com/thedeclarationofyou.

Has the timer gone off yet? You may be bummed to be back in the Real World, but we're here to find the *compromise*, the gray area that exists between here and YourNameHereLand. Were you happy, peaceful, enthusiastic, bright? For now, pick one word to describe that feeling, and break it down into smaller pieces. If your word is *happy*, what was it about YourNameHereLand that made you happy, and how does it translate to the Real World?

Use the Real World Actions worksheet to translate how you can bring about this feeling in your real life. Here are some examples:

FEELING: Happy

I FEEL *Happy* BECAUSE: the trees are purple.
AND THAT CAN TRANSLATE TO THE REAL WORLD BY: painting a canvas of purple trees and hanging it in my bedroom where I can enjoy it.

I FEEL *Happy* BECAUSE: I spend my time reading in a comfy hammock.
AND THAT CAN TRANSLATE TO THE REAL WORLD BY: carving out time to read in my favorite chair every week.

I FEEL *Happy* BECAUSE: there's a beach in my backyard.
AND THAT CAN TRANSLATE TO THE REAL WORLD BY: spending a weekend on a beachfront property; buying a CD of beach sounds.

When you're done, extract the words or feelings from the worksheet that sum up YourNameHereLand and go to town on the YourNameHereLand Feelings worksheet. It's a great reminder of how you want to feel day-to-day!

Let's now commit to focusing on actually bringing one of these "translations" to fruition. The way we'd suggest to delve into it is . . . are you sitting down? . . . **to do what feels easiest.** Yep. Close your eyes, take a deep breath, and ask yourself what would fit the best in this moment.

For example, Michelle says,—

Before I dove into an hour of writing here, I knew I could alternatively write a blog post or clean my apart-ment. At that moment, I sat with myself for a while and asked which task would feel the least like a struggle. I knew instinctively that I wanted to crack open The Declaration of You and make my contribution for the day. Everything else was taken off my plate (mostly) guilt-free.

Whether you're most excited about painting those purple trees or booking the beach retreat, set a timer for forty-five minutes right freakin' now and make a dent in creating your successful life!

We'll wait.

Now, let's get back to the definition of "success" that'll be all yours, and let's use the Why It's Important worksheet to find it.

Going back to the previous example, you might write, "Painting a canvas of purple trees and hanging it in my bedroom" in the left column. Then, it the right column, you might write, "Because purple trees would remind me of my whimsical side every time I look at them."

Don't stress about using everything you have listed. Instead, see what can be grouped together and what you instinctually feel is key to your personal success. From the examples above, this might be the definition:

"I define success as living a life of whimsy while being financially secure and making time to prettify my space."

Your turn! Time to fill in the blank:

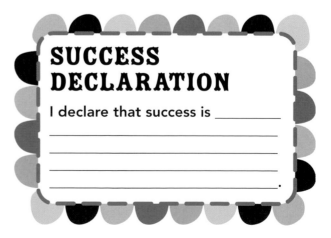

SUCCESS DECLARATION

I declare that success is _____

_____ .

TOPIC: Real World Actions

I feel _____ because...	And that can translate to the real world by...

TOPIC: YourNameHereLand Feelings

TOPIC: Why It's Important

(Key activity pieces)	is important to me because...

Your Perfect Day

Take some time out to think of your Perfect Day. Where would you be? Who would be with you? What would you be doing? If nothing's coming, close your eyes and take the pressure off yourself. Just wait for it.

Once you have that image or that movie in your mind, write it down or draw it or paint it or make it into a cartoon. If that doesn't cut it, make a vision board of it and put it someplace you'll see it at least twice a day. Let yourself look at it. Daydream.

Like we mentioned in the Intentions chapter, ask yourself what you're willing to believe. Add that to the vision board, too. Just make sure that you slay the Vampires that come out while you're doing this, especially the Yeah-Like-That'll-Happen Vampire and the I'm-Not-Qualified Vampire and the I-Can't-Really-Make-Money-From-That Vampire. They're not welcome here.

The Goal Game

Choose one goal. Yep, just one. If you're having trouble figuring out which one, write down all the goals that are rattling around in your head and pick the one that you feel would make you the happiest. Break down that goal by pretending you've already accomplished it, listing all of the steps that you took to get there. Don't forget to write down a celebration task every two to three steps to keep you going.

Don't be tempted to do this with more than one goal until you reach this goal! Otherwise, that whole making-yourself-crazy thing is bound to take over. Trust us on this one (aka, we've done it ourselves). It might be tough to allow yourself only one goal, but fully focusing on that goal and having the perspective that you've already done it will not only give you better results in achieving it, but will also enable you to better enjoy the journey! The Goal Game and Baby Steps worksheets will keep you on track!

Need to Know

Using the I Think I Should Know worksheet, make a list of all the things you're telling yourself you should know about your project or your goal. If you can't replace the word "should" with "want" or "need," cross it off the list. ("Shoulds" come from an outsider and they're not the boss of you.) Then, next to each item that remains, write the reason behind why you think you "want" or "need to" know that. If it's anything close to, "Because I need to or else I'll fail!" cross it off the list. That's just you thinking you need to know something, and it's baloney. If the reason is something else (e.g., "I want to know how to knit because I'd love to make something homemade and special for my baby niece"), write down all the people who can help you learn. Then, ask for help. If that's scary, offer to barter: a knitting lesson from your colleague in exchange for a makeup lesson from you. How is that not a win-win?

The Goal Game

My Goal: _____

MY PRIZE!
(could it be to enjoy some garlic fries?)

STEP 4 (open that door):

STEP 5 (don't you feel alive?):

STEP 3 (is great as it can be):

DON'T FORGET THE CHUTZPAH!

Celebration. Bribing yourself is awesome.

Honesty. Be honest with what can be acheived.

Unique. This is not yo mama's goal.

Timely. Due dates are your friend.

Zest. If it inspires jazz hands, you're on the right track.

Precise. Timing is everything.

Assessable. Know when you've rocked it.

Honor. Savor the win by really celebrating!

MY PRIZE!
(do you want some brand new ties?)

STEP 2 (is up to you):

STEP 6 (are you getting your fix?):

STEP 1 (is really fun):

STEP 7 (it's just like heaven!):

START HERE
Give a cheer!
When you're done you'll have a beer!

CELEBRATION!
(Tell the entire nation!)
You're all done! Ain't it fun? You are super number 1!

TOPIC: Baby Steps

Baby Steps:	Reward:

TOPIC: I Think I Should Know

Things I think I should know:	I think that because:

SUCCESS (own it!)
Kelly Rae Roberts

TDOY: *We know that you use your intuition as one of your main business tools. How do you think following your intuition can influence success, both in business and in life in general?*

KRR: I think it's everything. When I think about all of my business (and life) tools that I store in my toolbox, intuition is the most powerful. At its very core lives the essence of OUR voice, and our voice and sincere presence in our businesses are the absolute number-one secret ingredient to making it all rewarding, worthwhile, and incredibly effective when it comes to things like branding, marketing, and inserting as much soul as possible into our businesses (and lives).

TDOY: *The thriving creative business that you've created is an inspiration to many—not only your uplifting artwork, but also your willingness to share your knowledge and experience with others in order to help them create their own successful businesses. How do you think this generosity and openness has helped in the success of your business?*

KRR: It's been hugely helpful. I essentially have two branches of my business: an art business where I sell my art, license my designs, etc., and an information business where I share everything I've learned along the way when it comes to building a creative business. My information business was born out of a sincere desire to share and be open with my resources and information because when I was starting my own creative business, I had a very hard time finding anyone who would share basic information and resources with me.

I promised myself that should I have success down the road with my creative biz, that I would share all the resources openly, and that's what I've done. It's become a part of my mission to mentor and inspire other creatives to GO FOR IT. I absolutely understand that we can't (and shouldn't) share certain things that are proprietary, but I can certainly share my tricks, resources, and valuable information to help others along in their business paths.

I deeply believe there is room for all of us, and the more of us having success doing what we love to do, the better. The result? The decision to start the information branch of my creative business has proven to be hugely successful for my overall brand and constitutes about half of my total income. Its success has fed into my art sales and vice versa. The mission with both is the same: to help others discover their own limitlessness in life, in art and in business.

TDOY: *How has your idea of success changed since you started your creative business? What did success look like to you before you found your creative calling, and how did you let go of old notions about yourself to embrace new beliefs around success?*

KRR: Being a creative business owner has taught me more than I ever thought I would learn about life, and one of the biggest lessons it has given me is the perspective of success. Over the years, I've learned that success to me means this:

- Success is understanding that WE GET TO CHOOSE. We get to choose what we do, why we do it, who we work with, who we work for, how we conduct ourselves inside our businesses—all of it. It took me a long time to realize this prior to creating my own business. Eventually I found that success felt really alive in my heart and in my business when I stopped thinking or acting as if there was a right way to create and maintain a business.
- Success in business (and in life) is knowing that we can be crazy financially successful but that shouldn't change one's groundedness or center. It means walking the line of celebrating financial success while also being just the right amount of unattached to it so that while your dreams and goals are up high flying in the sky of potential, your heart and your ego and your true mission remain firmly planted in the ground.
- Success in business (and in life) is knowing that we have the capacity to handle it all; that we can be wise and brilliant one minute and vulnerable and tender in the next. Success is understanding that it all matters, and that we have the capacity for the full breadth of human experience inside the life journey of our businesses.
- Success is bumping ourselves up against our edges. As we accomplish what we say we're going to do, a new edge is created, which means another step further into the horizon of our potential.

TDOY: *We live in a saturated, visually stimulating, and super-connected world, and it's easy to get sucked into other people's versions of what our successful lives are "supposed to" look like. How do you tune out others' ideas of what success is so you can listen deeply to what your own heart is telling you success means for you?*

KRR: This is such an important question. Early on in my creative career, I thought that teaching at big art retreats meant that I would be successful, only to realize that I actually didn't love teaching art workshops very much at all! I was just caught up in what other people (people I admired and looked up to) were doing and thought that if I could do it, that it meant I'd also be successful. I changed course a bit in my path and got a lot more intentional about the choices I was making. I then chose the options that felt most like home to my heart and spirit, despite what others were doing or what I thought others would think of me if I wasn't teaching, etc.

I think all of this takes practice. Sometimes we don't even know what our intuition is telling us because it's buried underneath all the messages. To this day, the thing that helps me tune out those messages is to surround myself only with people who inspire, uplift, and support my version of success.

TDOY: *What's your personal declaration for success?*

KRR: Success in business (and in life) is not playing small, but bravely and fully stepping into my own voice, my own power, and really SEEING myself as the possibilitarian that I am. That, and gratitude. Gratitude is essential for understanding that success is often a matter of perspective.

Kelly Rae Roberts is an artist, author, and possibilitarian. She is the author of *Taking Flight: Inspiration and Techniques to Give Your Creative Spirit Wings*, a best-selling book featuring her insights on the creative life as well as her popular mixed-media techniques. She is also the author of *Flying Lessons: Tips and Tricks To Help Your Creative Biz Soar*, a popular e-book series. Her work has been featured in a variety of books and magazines, including *Where Women Create, Artful Blogging, Cloth Paper Scissors, Somerset Life, Somerset Studios, Memory Makers*, and more. Much of her artwork is licensed and can be seen in stores nationwide on a variety of gift and home decor products. She currently lives in Portland, Oregon with her outdoorsy husband, John, her baby son, True, and their airplane-eared dog, Bella. You can see more of Kelly Rae at www.KellyRaeRoberts.com.

SUCCESS (own it!)
Jennifer Lee

● ● ● ● ● ● ● ● ● ● ● ● ● ● ● ● ● ● ●

TDOY: *You spent ten years climbing the corporate ladder and working for large, powerful companies like Gap Inc. As successful as you were in that part of your career, what about it didn't align with your definition of success?*

JL: Sure, my corporate job looked really good on paper. I was making a great six-figure salary, I had visibility to high-level, powerful executives, and I had the title and position I strove for when I entered into the field nearly a decade before. But I wasn't happy or fulfilled. I felt like I couldn't bring my true, authentic and creative self into my work. I worked a ton of hours. I wasn't living my life on my terms. Frankly, my career was sucking the soul out of me. I had put too much emphasis on external definitions of success: money, status and material things. Now that I work for myself, I feel like I can stay more aligned to my own internal and personal definition of success, which includes living

joyfully, honoring my core values, having a positive impact on others, expressing my creativity and following my own natural rhythms (including being able to take a nap in the middle of the day if I want!).

TDOY: *On your website, you wrote that you left your job because you needed to "walk the talk" after leading a retreat and encouraging the attendees to live their big dreams. What obstacles did you have to maneuver through to make that leap, and what tips do you have for people who want to make the same type of transition?*

JL: I'd say one of the biggest obstacles was trusting in myself—trusting that I had the courage to make the leap, trusting that even though I didn't know what I was doing most of the time, I was resourceful enough to figure it out. Another obstacle was not having a really strong support structure in the entrepreneurial world. The majority of people in my network were folks still climbing the corporate ladder. I knew that I needed to connect with like-minded folk who were also following their dreams, so I began to cultivate relationships with other entrepreneurs and creative souls.

If you want to make a similar transition, I recommend starting to explore new things outside of your day job to figure out what you're passionate about. Begin to build your business on the side so it's easier for you financially to invest in things like classes and training. And I think most importantly, find your circle of support. You're going to want to have friends, colleagues, experts, mentors, and other cohorts to turn to when you need encouragement,

valuable insights, feedback, or a good, loving kick in the pants to keep you moving forward!

TDOY: *You wrote The Right-Brain Business Plan: A Creative, Visual Map for Success (which we love and recommend to everyone!). Why do you feel it's important to have a visual representation of your goals rather than a more traditional way to articulate what you want?*

JL: You've heard the saying, "A picture is worth a thousand words." Visuals help you intuitively access feelings and thoughts beyond words and help you quickly connect with the essence of your goals. Plus, they make an inspiring tangible reminder to help you stay in touch with your big dreams. Sure, having your goals written down in black and white is helpful. But having them come to life through vivid colors, images, textures, and three dimensions can make your goals seem more real and attainable.

For example, several years ago when I got really clear about wanting to write a book, I prototyped the front and back covers and pasted it to my journal. It was cool to have something physical that I could hold in my hands to motivate me on my journey. You can use visuals to get the overall big picture of your dream and then detail out the action steps and resources needed to make it all happen.

TDOY: *What's been the accomplishment that you're most proud of, and why?*

JL: I'm most proud of leaving my corporate career to pursue my passions. That milestone was significant on so many levels. It was a culmination of a lot of deep, personal-growth work leading up to the transition, and it was the opening into so many other dreams coming true. By taking the leap, I have been able to really step into the life that I want.

TDOY: *What's your personal declaration for success?*

JL: Success is living life in full color!

Jennifer Lee, CPCC, PCC, MA, is the founder of Artizen Coaching (www.artizencoaching.com) and the award-winning author of *The Right-Brain Business Plan: A Creative, Visual Map for Success*. Her best-selling book has helped thousands of entrepreneurs around the world grow their businesses authentically and creatively. After spending ten years climbing the corporate ladder and getting tired of living her dream "on the side," she took the leap to pursue her passions full time. Jennifer received her coaching certification and leadership training through the prestigious Coaches Training Institute. She is also a certified yoga instructor, a certified Expressive Arts Facilitator, and holds a B.A. in Communication Studies from UCLA and an M.A. in Communication Management from USC. She lives in the San Francisco Bay Area with her creative, rather left-brained husband and their beautiful husky-lab mix.

To watch an extended video interview with JENNIFER LEE, go to www.createmixedmedia.com/thedeclarationofyou. (There's an audio version there, as well.)

SUCCESS (make it!) ●●●●●●●●●●●●●●●●
YourNameHereLand Collage

Just as with your personal success, the sky's the limit on this one! Use your poster board to create YourNameHereLand by gluing and drawing everything that you visualized earlier in the chapter. In PierreLand, you'll see that Pierre François Frédéric is riding Jean-Luc Zee Blue Pony, and there are some ladies (who we all know he adores!), an Eiffel Tower and a PierreLand legend—feel free to make your own legend. Make a flag for YourNameHereLand or whatever you can dream up! Don't worry about making it perfect or beautiful. The point is just to have fun! As you can see, ours is nowhere near perfect, but we had a heck of a good time making it.

What You Need

- poster board (any size)
- magazines
- scissors
- rubber cement or glue
- glitter
- sequins
- markers
- fabric
- any other crafty things you have around the house that you'd like to use!

1 Gather up the crafty supplies that make you smile.

2 Begin with the name of your land.

3 Cut images from magazines that represent the things you'd expect to see in YourNameHereLand and glue them to your board, or draw the things yourself.

4 Using glue, apply other textural elements to your board, such as sequins or colorful feathers. You can also add elements by hand with pencils or markers.

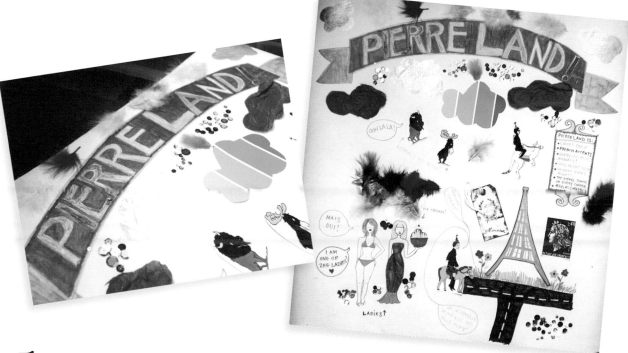

5 Remember there are no rules here. When you are finished with your collage, post it in a place where you can remember daily what success looks like to YOU.

To watch our SUCCESS video, go to www.createmixedmedia.com/thedeclarationofyou. (There's an audio version there, as well.)

MONEY ●●●●●●●●●●●●●●●●●●●●●●●●●
(discover it)

Most of us might say that money doesn't buy happiness or isn't a true measure of success. And with that, we'd abso-undoubtab-lutely agree. But we also know that money—specifically, our beliefs around it—holds us back, sometimes more than anything else. Most of us probably wish we had more money than we do, right? Whether we're worried about it going out (never to be seen again, we think) or coming in (which could never actually happen, we think), money usually stops us before we even start. Most of us have been told, "You can't make a living as an artist," and then been asked, "So, what's your back-up plan?" Even though we see other people actually doing it, we think that they're not anything like us. They're "special," "charmed" or "lucky." We can't possibly make that happen, so why even try?

Here's the thing.

Your beliefs around money determine what's possible in your life, plain and simple. Your beliefs, both positive and negative, have a heck of a lot to do with living the kind of life you want to live. If you believe you're not capable of earning more than, say, $40,000 a year, you probably won't ever earn more than that because that possibility just doesn't exist in your imagination. If you believe you

can't make a living as an artist, you probably never will. If deep down you believe it's impossible for you, it's pretty close to impossible that it'll ever happen in your life. That belief shuts out all possibility for creative ways to allow it into your life. We know it sounds harsh, but think about it. If you don't think something is possible for you, how could it possibly ever show up in your life? And those people who we think are "lucky" or "special" are actually just people like us with a different set of beliefs. Change your beliefs, change your outcome. We know it sounds a little woo-woo, but it's true! And those "lucky" people have most likely worked pretty darn hard to get where they are. They're not lucky—they're hard-working people with big ideas and big beliefs to match them!

You have to believe that you are WORTH earning and having whatever amount of money you desire to have. You have to believe it's POSSIBLE to have any amount of money you desire, even if you have no freakin' idea how you will ever earn that money. You don't have to know yet! You just have to believe the possibility exists. You have to believe you're worth it. Having money doesn't bring happiness, but it does allow us to do the things that make us happy. We'd argue that living a life free of financial worry would make most of us much happier than living with that worry and fear.

We're not saying that believing (really truly believing) that you are capable and deserving of making more money will make money rain out of the sky onto you and that you'll be able to live your wildest dreams. What we ARE saying is that once you let your mind play with different ideas and beliefs, new experiences will start to arrive in your life.

Jess says—

I'll give you an example. For a long time, I held the belief that I couldn't spend any extra money that wasn't absolutely necessary because I never knew when I might all of a sudden never make money again. (Yes, you can laugh if you want, but it was a real fear! Fears aren't usually rational, you know.)

I rarely spent money on anything for myself outside of the bare necessities. I felt like I needed to hoard all my money "just in case." I've slowly learned to let go of that "just in case" feeling and lighten up my beliefs around money a bit. I do nice things for myself now. I buy things just for fun sometimes. I don't obsess over every dollar and cent that I spend. I'm not saying I'm irresponsible with my money now—far from it. I just understand it differently now.

I've also noticed the less I hoard my money and hold that scarcity attitude, the more money flows into my life.

It seems strange, but it's almost like you're saying "OK, money. I trust you. I'm just going to spend you when I need to and know that there's going to be enough of you in my life!" The more you trust money, the more it will be there for you.

So now it's your turn. Using the Beliefs About Money worksheet, write some beliefs you have about money that might be getting in the way of you living the life you want to live in the left column. In the right column, change those negative beliefs into positives, like this:

MY MONEY BELIEFS THAT ARE GETTING IN THE WAY:
There might not always be enough money, so I need to save it all in case something bad happens. I can't spend more than I absolutely have to, in order to survive.

INSTEAD I CAN BELIEVE: There will always be enough money. I am allowed to use my money to enrich my life and make it easier and more fun.

Even if the belief seems really dumb to you, write it down! We'd argue that the dumber it seems to you, the more potent it probably is. Get 'em all down on the list! You can add to the list, too, whenever you discover a new money belief that you hadn't realized before. It might be hard to believe those statements in the right column at first, so we encourage you to go back to the Intention chapter where we talked about creating statements with the words "I'm willing to . . ." That exercise might be a useful way to start incorporating those new beliefs into your life!

Since I do not have a job, I must rely on my charming personality and good looks to get what I want, but look where it got me! I am zee host of Zee Declaration of You! It pays to be yourself!

TOPIC: Beliefs About Money

My money beliefs that are getting in the way:	Instead I can believe:

Even if you're not looking to make money from a pursuit some might call "unstable," such as being an artist or an entrepreneur, money (or more specifically, money fears) might be stopping you from trying something you want to try or giving yourself some self-care love in the form of massages, spa days or new L.A.M.B. handbags (Michelle note: not that I'm coveting any of these things personally [please note sarcasm]). We're not saying to ditch all your responsibility around money and go on a crazy shopping spree or anything. We are saying that spending money on things you value is a terrific way to reinforce your positive money beliefs.

Because the truth of the matter is that, well, money does play a part in our happiness. Arguably, the more you aren't living hand-to-mouth, the more you're enjoying your life. Think about what's been the source of stress, anger or frustration lately. Is money at the root of those feelings? If you had more money—and we're not talking lottery money here, just enough to live above your means—would you be more calm, peaceful, grateful, happy?

And what's the point of having money if we're not going to use it to live our best lives?

Let's do a little exercise. Use the Money Spent This Week worksheet to write down everything you've spent money on in the last week. You don't need to write any dollar amounts, but do try to list everything that you can remember (e.g., laundry, coffee, groceries, cab fare, a bottle of wine or three).

When you think you're done, highlight which items bring you happiness. We're not talking singing-to-the-birds-à-la-Snow-White happiness, but things that make your life better, easier, less stressful. For example, sending the laundry out each week to be washed and folded, or the iced coffee you buy at the local coffee shop so you can do your work on a sunny patio all afternoon instead of staying inside in your home office.

Also, take a moment to note whether you were surprised by any areas where you spend more money than you thought you would, or more than you're comfortable spending in that area. Maybe there is some wiggle room there where you can re-allocate some funds to different activities that bring you more joy, or use that money to start a savings fund?

Now on the Current Happiness Value worksheet, use the left column for the items you highlighted and the right column to get down "The Value It Gives Me."

Finally, on the Desired Happiness Value worksheet, write down all the things that you've been wanting to spend money on in the left column, and the value it would give you in the right column. Yep, you can add something as small as a bouquet of flowers from the deli all the way up to something as big as a houseboat in Amsterdam.

Notice any common threads in the values sections of both charts? Write down the ones that appear at least twice and/or seem super-important.

Can you see that money is about enriching your life, giving you the chance for more enjoyment and experiences each and every day? We're not saying to max out your credit cards or take your inheritance and turn it into diamond rings. But think about it: Would you have as beautiful a day staying in your cube for eight straight hours if you didn't take twenty minutes to buy an Italian ice at the corner pizza shop? Would you enjoy your art as much (and be able to grow your business) if you didn't purchase the printer that would make your Etsy offerings top-notch? And going back to the beginning, would you have even picked up those brushes or invested in that yoga class had you let your fear of finances stop you?

It's time to make your declaration, using the common threads you listed above!

MONEY DECLARATION

I declare that money adds value to my life by _____

_____.

TOPIC: Money Spent This Week

Everything I have spent money on this week:

TOPIC: Current Happiness Value

Things I spend money on that bring me ease/happiness:	The value it gives me:

TOPIC: Desired Happiness Value

Things I have been wanting to spend money on:	The value it would give me:

Savvy Splurging

We know it can be tough to justify spending hundreds of dollars on classes or supplies for something that you're just starting to do (or want to try) or that you don't wanna invest your entire life into. Instead, think outside the box to make things more affordable.

Michelle has an example—

I love doing yoga, yet the local studios near me charge $17 per class for the most popular dates and times. Instead of paying that, I take their special $10 or donation-only classes mid-afternoons to still have the experience, but not leave such a hole in my wallet.

Look for salons or coffee shops that offer punch cards so you get the tenth cup of joe or manicure on the house. Use Groupon to see what you can buy at a discount in a city near you. (Tip from Jess: Just the other day I saw a beginner watercolor class for $45!)

Restaurant.com offers $25 gift certificates to local restaurants for just $10, and Vistaprint.com offers discounts on custom business cards and other office products on a regular basis. Use the Inexpensive Indulgences worksheet to create your own list of resources that'll allow you to treat yourself to delicious food, pampering, and awesome-tastic classes and experiences.

Money Choices

Using the Money Choices worksheet, first fill in the "Thing I Do" column with the ways that you spend money. For the second column—"Category"—write something such as "need," "obligation" or "want." For the third, write how you'd choose to do that thing if given a choice. For example, you might write "do laundry," "need," "have a service pick it up, wash it, fold it, and drop it off." Notice when it's money that's holding you back from doing what you choose to do, and see if you can turn more of those choices into your reality, even if you need to compromise (e.g., use the laundry service once a month instead of for every load).

Visualize It!

Figure out the amount of money you'd need annually to live comfortably (e.g., not worrying about over-drafting your checking or having to use credit to make big purchases). If you're having trouble with the figure, make a list of your expenses: rent/mortgage, approximate food/toiletry needs, cable/phone/electric bills, student loan and credit card payments, and enough outside activities to make you not feel like a shut-in. Got the number? Good. Now add 50 percent to that.

So, if your original number was $50,000, it's now $75,000. Take that number and write it down on a nice piece of paper and embellish/decorate it a bit to make it special. We provided some fun examples (see Topic: My Money Goal, following the Money Choices worksheet) which you could photocopy and cut out, or, of course we know you can doodle your own. You can hang this Money Goal on the inside of your medicine cabinet. You can write it on the back of a business card and put it in your wallet. You can tattoo it backward on your forehead so you can see it whenever you look in the mirror. Or you can do all three, as long as in your mind you start living in that number.

No need to stress about how that money's coming, or what you'd have to do/sell to get there and whether or not it's realistic. Throw all that away, and choose to believe that you're going to make that number this year and keep it in the forefront of your mind. We have a feeling you'll be surprised at the outcome.

TOPIC: Inexpensive Indulgences

LIST 'EM HERE

NOW GO INDULGE!

TOPIC: Money Choices

Thing I do:	Category:	Choice:

TOPIC: My Money Goal

My Money Goal:

My Money Goal:

MY MONEY GOAL

MY MONEY GOAL:

My Money Goal:

my money goal:

MY MONEY GOAL

My Money Goal:

MY money goal:

my money goal:

My Money Goal:

MY MONEY GOAL:

MONEY (own it!) ●●●●●●●●●●●●●●●●●
Alexandra Franzen

TDOY: *You gave Minnesota Public Radio / American Public Media—your dream company! — four months' notice that you were leaving your job, but you gave that notice not knowing how you were gonna bring home the bacon. A lot of us are so scared to do that. How did you trust that you'd find what you'd love and the money would follow?*

AF: The truth is, I *didn't* completely trust that I'd be able to find my life's calling and start rakin' in the cash, as an entrepreneurial writer. I was venturing into the wilderness. Failure was a distinct possibility.

To deal with the rollicking uncertainty, I created a miniature mantra: No matter what happens, I can take care of myself.

If everything imploded, I could always work at a dive bar. I could eat government-issued cheese. I could live in a dingy apartment in Podunk, Nowhere, USA. I could pawn my Dolly Parton CDs and bleach my hair platinum blonde. It would have a certain Depression Era romantic charm! And I would *survive.*

By articulating my absolute worst-case scenario—right down to the saltine crackers and second-hand Kmart jeans—I took the hysteria out of my Plan Z. My worst-case scenario became . . . just potential fodder for my memoir.

So I didn't have *trust* or *conviction* or *confidence*—not at first. But I had something better: the willingness to crash and burn. To just . . . *try.*

TDOY: *As of this writing, you charge $1,500 to work with a copywriting client for a one-day Velocity session, and you have a six-month waiting list! Amazing. How did you step into your own worth, and how do you respond when people say you charge too much?*

AF: I didn't arrive at the $1,500-a-day mark overnight. Like most newbie entrepreneurs, I initially undercharged and overbooked myself in an effort to get things rolling—and, y'know, pay the bills.

But once I launched my signature offering—a one-day self-promotion and storytelling immersion called Velocity—I realized that what I was selling was much more than a ten-hour block of brainstorming and copywriting. I was offering a chance to remember who you are, reveal who you're becoming, and have your highest mission on the planet spun into words by a masterful scribe. Right there. On the spot. In a single day. BOOM.

Once I got my noggin out of the dollars-per-hour consulting mind-set and started to grasp the larger effect of my work, raising my rates made sense—and felt right. I wasn't offering a chunk 'o consulting after all. I was offering a powerful, luxury *experience* with a powerful, luxury pricetag to match.

TDOY: *You talk on your blog about how when you step into what you're passionate about, it should feel easy and fun and be lucrative. What changed for you when you stepped into this role that you're obviously called to do?*

AF: I genuinely believe that work, relationships, making money—this whole mysterious game we call life—is all supposed to be EASY. And when I say "easy," I don't mean that you get to be passive, lazy or entitled. I'm talking about a natural sense of attraction, fluidity, swiftness and synchronicity. It is the difference between fighting a river upstream, dodging whirlpools and tree stumps and salmon-crazy bears and cruising downstream with the pull of the current.

Woo-woo nature metaphors aside, life *isn't* always easy. Sometimes, due to external circumstances; often, because we love to question, overburden and generally muddle with the inherent ease of things.

This might sound overly simplistic, but for me, making money got a LOT easier when I start packaging my time and skills in a way that felt . . . *easy*. As in: natural, effortless, obvious, ideal for *me*. And once I shifted from clunky to easy, people started responding—in spades. Ease is magnetic, like that.

TDOY: *Some people—especially women—equate making money from their passion with being greedy or slimy. What would you say to these women?*

AF: Is it greedy or slimy to be recognized for your work? To receive hard-won praise from a beloved mentor? To get a handwritten thank-you note from a girl on the other side of the world? To get profiled in a book, documentary or international magazine?

Receiving money for your work is just another form of public recognition. Think of it as a vote of confidence—one of many signals that what you're providing is valuable, necessary, informative, entertaining, educational; that it adds to the excellence of the world. Excellence is *anything* but slimy.

TDOY: *What's your personal declaration for money?*

AF: I actually wrote a manifesto about money called Money Amplifies Your ART. Here's an excerpt:

Money cradles + energizes who you already are.
If you are artful, money will amplify your art.
If you are adventurous, money will give you new ways to be bold.
If you are kind, money will stretch your compassion to the ends of the earth.
If you are playful, money is a playground you hold in your pocket.
If you are romantic, money can bolster your expressions of love.
If you are optimistic, money will show you an entire world of potential.

With laser-lucid copywriting and quick poetic instincts, Alexandra Franzen helps best-selling authors, elite coaches, wellness warriors and spiritual leaders find their voices, claim their online territory, and channel their skills into products, services and entirely new businesses. Find her at AlexandraFranzen.com and on Twitter at @Alex_Franzen.

To watch an extended video interview with ALEXANDRA FRANZEN, go to www.createmixedmedia.com/thedeclarationofyou. (There's an audio version there, as well.)

MONEY (own it!)
Kari Chapin

● ●

"Hey, I love BRAND XYZ shoes; I own six pairs! I stand on my feet all day, and they really help. You should check them out!" We all sell what we truly love to people we meet; we do it all the time. For some reason, that darn ego seems to get in the way for many creatives when it comes to marketing themselves, and people get shy about tooting their own horn. Think about what products you most love, and how you would recommend them to a friend, or stranger, and then apply that passion to describing your own work or talents.

TDOY: Besides being an author, you're also a teacher, a speaker, and a consultant. Have you ever had a roadblock in making money from your offerings? If so, how did you get past it?

KC: I have always been very comfortable with what I charge for my personal services, like consulting and speaking. However, I did have a problem of helping people in my personal life for free, and I felt, after a while, that it impacted my earnings. People I knew would talk to me about their businesses, and while I am always interested in what my friends or community members are doing, I had to learn to stop giving them advice unless they asked for it directly. This was, and still is, really hard for me. Learning to set those boundaries has been a challenge, but I'm glad I started working on it. It has made a huge difference in how I feel about my own value as an expert, and I feel much more authentic when I'm dealing with people close to me.

I deal in words—spoken and written—so it's hard to manage that sometimes. Naturally, if I was a painter or a landscape designer, it would be much harder for me to give my services away for free. Since my work is my words, my thoughts, my ideas, my concepts, they sometimes just

TDOY: You're the wildly successful author of The Handmade Marketplace and Grow Your Handmade Business. What have you found to be the biggest barrier creatives have in selling their work?

KC: I find that a lot of creative people are afraid to really get out there and promote themselves, which leads to other issues that need to be dealt with down the line. If you can't talk up your work, or even just talk about it comfortably, how can you sell it? If you can't sell it, how can you make money? I think most problems can be traced back to an unwillingness to really stand up for what one does, sell it, speak about it, push it, and make it work for you.

If you love a product or service that you use in your daily life, you're comfortable telling everyone about it. Like,

fall out of my mouth. Learning to control my enthusiasm has been tricky.

An example of how I chose to deal with this is by bartering for services. That way I'm not asking my friends to pay me for my thoughts, but I don't feel taken advantage of either. Once I realize the conversation is heading in that direction, I simply say something like, "I could help you with that problem. Maybe we could trade services." This has worked really well for me.

TDOY: *Many creatives often equate making money with being greedy or selling out, and often undervalue their worth. Any advice to help them attain a new perspective?*

KC: I think it's so funny that most people have no trouble feeling underpaid when they work for someone else. It's easy when one is slinging the 9-to-5 routine to feel like they deserve so much more: more money, more satisfaction, more acknowledgment, whatever. Yet, when one works for oneself, it's so easy to feel like we deserve less! I say NO WAY to that! It does not serve you to undervalue what you do. After all, who wants to work hard to make their work-for-themselves dreams come true, just to realize that they aren't making enough money or to have the stress of not feeling good about what they do all day?

Working for yourself is Hard—Hard with a capital H. But it's also so worth it. *You're* worth it. Your work is worth it. How would you advise your best friend if she was feeling like a sellout? What would you tell her about her worth? About selling out? Give her a pep talk in your head. Pour your heart into it. Build her up! Now do the same thing for yourself, and actually follow your good advice and take your compliments to heart.

TDOY: *Do you feel there's a correlation between believing you can make a certain amount of money and actually reaching that goal?*

KC: YES! If you can believe it, you can do it. And that goes for more than making loads of cold, hard cash. I'm a huge believer of creative visualization and positive thinking, but it goes way beyond that. I'm a huge believer in positive *knowing* and processing. If you can't believe it can happen, it won't, because your energy will be directed elsewhere.

TDOY: *What's your personal declaration for money?*

KC: I like money, and it likes me. I deserve money. I am good at earning money. I am not afraid of money. Me and money are good together; we make a great team. I control money; it does not control me.

Kari Chapin is the author of the best-selling books *The Handmade Marketplace* and *Grow Your Handmade Business*. She combines her background in marketing and publicity with an avid enthusiasm for creative businesses to offer personal coaching and creative business consulting. She is also a sought-after public speaker and teacher. You can find out more at www.karichapin.com. Connect with her via Twitter, @karichapin or on Facebook.

MONEY (make it!)
Pierre Money

● ● ● ● ● ● ● ● ● ● ● ● ● ● ● ●

This is a fun little exercise to help you track your expenses! You can use as many different categories as you'd like. Some good ones to start with might be food, transportation, rent/mortgage, clothing, self-care, etc. Sure, you can track clothing, nails, and hair separately, as well as gas and subway tickets and cab rides separately, but for the sake of not going crazy, let's generalize it just so you can get an idea of where your money is going each week/month.

Once you figure out the categories, start tracking. Save receipts, write everything in a little notebook, use mint.com, write it on scraps of paper and put them in the pockets—whatever method works best for you! At the end of the week/month, add up your receipts by category and see how close (or far away!) you are to your Pierre Money number.

This is a great way to not only see where you can cut corners and save more, but also where you can spend some extra on the Important Stuff like self-care or piano lessons or the new side business you want to start.

What You Need

- poster board
- colored paper
- glue or tape
- scissors
- markers
- Pierre Money (photocopy or visit www.createmixedmedia. com/thedeclarationofyou to download a larger image)

1 Gather up your supplies.

2 Cut up your Pierre Money so you have a dollar for every category you want to track. Cut your colored paper into strips that are a bit bigger than the Pierre Money (they're going to serve as pockets for the money). Write one category that you'd like to track in your life (for example, utilities, transportation, food or fun) on each strip.

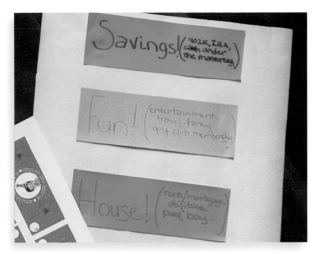

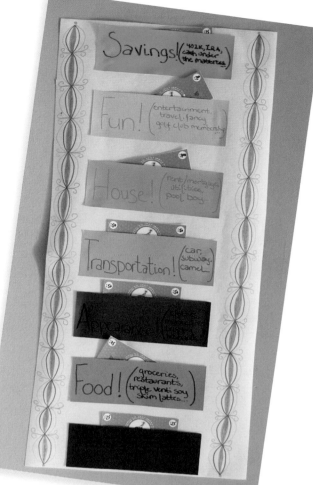

3 Glue the category strips to the poster board by running a small bead of glue along three of the four sides, leaving it open at the top. (Note from Michelle: This might seem obvious, but I neglected to glue down the bottom of the pockets, and Jess had a good laugh when the Pierre Money fell onto the floor. Thankfully, I'm adorable.)

Arrange the strips on the board in any order you like. As you can see, we chose an attractive up-and-down formation.

4 Write in the dollar amounts in the blank areas on your Pierre Money that you estimate you spend each week/month (you decide!) for each category.

5 Place the appropriate Pierre dollar bill in the corresponding pocket. Make sure the dollar amount is hidden! We want it to be a surprise at the end of your time-tracking week/month.

6 Hang it on your wall as a reminder to track your expenses!

Download a full-size sheet of Pierre Money that you can print out at www.createmixedmedia.com/thedeclarationofyou.

To watch our MONEY video, go to www.createmixedmedia.com/thedeclarationofyou. (There's an audio version there, as well.)

DECLARATION 7

CELEBRATION

CELEBRATION (discover it)

● ●

If you're anything like we are, you probably have mini-victories in your life all the time that you don't acknowledge. You reached one hundred sales in your Etsy shop (which you'd been hoping to do for months); you sold your first large painting (for more money than you ever thought anyone would pay for them); you set an intention to check your e-mail only once a day for a whole week and you actually DID it! Awesome things are happening all the time!

What are you doing to celebrate?

We live in a culture where working really hard is highly valued, and we're trained to want more, more, more. And most of us believe that when you reach a goal, you better move on as fast as you can to the next one, or you might FAIL! This is nonsense. We're here to tell you that it's OK to celebrate your mini-victories along your path to your wildest dreams! In fact, it's healthy and, we would argue, VITAL as well. It's so easy to get caught up in feeling like we're not doing enough, like the people we admire are so much farther down the path that we want to travel (and how are we ever going to get there?), that it's easy to just skip over the acknowledgment part of the whole thing. But how will you know how far you've come if you're not looking at what you've accomplished and saying, "Heck yeah, I did a good job!" along the way?

Jess says—

My favorite way to celebrate reaching a goal or finishing something big is going out to dinner with my husband. (I love to eat, remember?) Going out to dinner feels so celebratory, and we make sure to do it whenever one of us reaches a goal or finishes a project or whatever so we can talk about how it feels.

Celebrating the steps you're taking is a great way to encourage you down your path. If you know you'll get to celebrate by doing something fun when you've reached the next step, you'll be more willing to do the work. This relates to the Self-Care chapter, by the way, so you can probably even pull some of those things down and use them here. Because it's not really celebrating if you're not doing something nice for yourself! We are talking about YOUR victories, after all.

Make it fun, so it's fail-proof. *The Declaration of You* stemmed from the need, the want, and the desire to collaborate to help women learn about themselves in fun, playful, creative ways. We knew that, no matter the outcome, it was going to be a huge growth experience and a huge amount of fun. It's been fun fleshing this out. It's been fun putting it together. It's been fun getting to know each other better, as well as expanding our tribe to the incredible group of smart, ambitious, creative, funny women who have taken our e-course and have bought this book. There is no failing with this project. It's just not possible. It's too much fun.

To really put this into action, let's take a big project or goal that *you* want to work on soon. If you're having trouble coming up with something, think about the things you want to accomplish. Are any of them overwhelming? Do you not know where to start? Would it take multiple steps to see it through from beginning to end? When thinking about it for more than five minutes, are you worried that your head is gonna explode, but you wanna do it anyway? That's the one we want you to use! Don't worry. We'll be gentle.

Now it's time to think realistically. (We know, that was quick.) Go to your calendar. Consider your commitments. Be nice to yourself and make sure you're not cutting into sleep time or snuggle time or social time or whatever time you need to ensure your head won't explode (if we're proven wrong and your head does explode, we'll be very, very sad). Now fill in the dates on the Celebration Dates worksheet.

All done? Are ya suuuuuuuure? Are you positive? Are you absolutely positively quite undoubtedly sure that there will be no head exploding on our watch? If not, go back to the chart and tweak it until your commitment is a realistic one. When you're confident about it, move it along.

It doesn't matter if you start from the end goal and name the steps backwards or if you start at the very first baby step and work your way toward the goal—either way will work great.

Write the Big Idea at the top of the Celebration Dates worksheet (where it says "Goal"), and use the rows under "Breaks in that time period" for each *baby step* that will fit in your weekly time slot. See why this is italicized? Don't make it bigger than the time you have for it. Otherwise, head explosion. Here's an example where Michelle's goal was to take her career-change exercises and make them into a workbook:

- Pull all exercises into one document
- Revise
- Revise/hire graphic designer
- Send copy to graphic designer
- Create web page for it
- Final copy
- Send advance copies to my peeps / affiliate stuff
- Prelaunch

TOPIC: Celebration Dates

GOAL:

Celebration Schedule:	Time/Dates:
Weekly time commitment:	
Start date:	
End date:	
Breaks in that time period:	

Now let's assign some dates to the baby steps while keeping in mind how you work best. Would it help to write down the date you're going to commit to doing that step or the date it's due? Maybe it's most helpful putting four steps on your monthly calendar and doing them when the mood hits. Whatever way works best for you is the right way to do it.

With the best way you work in mind, feel free to use the Baby-Step Rewards worksheet for this exercise. You can even cheat a bit and pull some of the things you listed as ways you wanted to treat yourself in the Self-Care chapter and use them in the "Reward" column. (Yes, we're saying it's OK to cheat, as long as you keep your eyes on your own page!) You can even call it a bribery list if that makes it more fun and silly. We want it to feel fun and silly!

Remember, when you set the reward before you even start the task, it's absolutely a way to keep yourself going. When you were a kid, did your mom ever tell you that you could get ice cream or a prize at the drugstore if you didn't cry during your shot? It worked when you were a kid, and it'll work now, too. And no, we're not above it. Maybe after you reach one hundred Etsy sales you're going to take yourself out for the biggest banana split you can find. Ice cream almost always works as a bribe!

Use whatever words get you in the mood to start creating the most fun list you possibly can so you have some-thing to look forward to before you even start. Think of it as an adventure! Celebrating after each step is probably not your normal way of doing things, so you can look at it as one big experiment.

The goal of this experiment: to see if you feel differently after you've celebrated your way to reaching a goal than you normally feel when you've finished something. Our guess is that you'll feel a lot different than if you just put your nose to the grindstone and worked, worked, worked until you were finished. We're also placing our money on the chance that you'll have more of a sense of real accomplishment when you're finished, because you'll look at your steps and appreciate your work the whole way, instead of rushing onto the next step without any acknowledgment of your progress. And when the time comes to take your reward—which you will have justly deserved, by the way—make sure you do it while reflecting on the treat in front of you. As you dive into that banana split, know it's because of your one-hundredth Etsy sale. As you applaud at the end curtain of that show you've been dying to see, remind yourself that it's because of the product you just launched or the big client you just landed or the promotion you worked so hard for. Remember, you're not only rewarding yourself—you're celebrating!

And we're full circle.

Which means it's time for your declaration!

I celebrate every time I get a kiss from one of zee ladies. I celebrate by asking for another kiss!

CELEBRATION DECLARATION

I declare that it's important for me to celebrate my wins (both big and small!) because: _____

_____.

Visit www.createmixedmedia.com/thedeclarationofyou for fun extras.

TOPIC: Baby-Step Rewards

Baby action step:	Date to do/Due:	Reward (yes, reward!):

Task Sandwich

You know those tasks that you just don't want to do? Those tasks that just feel horrible and that you'll procrastinate on for days and days? We want you to eat them! Just kidding. Sort of. We love the idea of sandwiching not-so-fun tasks in between oh-so-fun tasks. Use the Task Sandwich worksheet to take the dreadful, icky stuff and surround it with the fun, delicious stuff! Now just DO IT before you think about it too much. You'll be knocking those unfun tasks out of the way in no time!

To-Do Celebrations

For every task you write in your calendar or on your to-do list, write the celebration or reward that'll come with it. By declaring your celebrations in advance, you know exactly what you're looking forward to, and it'll absolutely keep you on task. Then, when it's time for your celebration, make sure you know that you're celebrating because of a recent accomplishment. That way, you'll condition yourself to feel good about a win, no matter how big or small, and it might automatically come into your head when someone asks what you've been up to. Remember what you celebrated lately and you'll know what you've been doing right!

Gratitude Journal

Keep a Gratitude and/or an Accomplishment journal. It's tough to be sucked up by the Vampire of Despair when you're focusing on the positive. Add something new to it every day when you wake up or when you go to bed, no matter how small the win or gratitude is. Buying your domain or having a cup of tea or starting a new project are all something to appreciate and be proud of!

Own It!

Drink in a compliment. If it's contained in an e-mail, read it two or three (or ten) times. If it's coming from someone orally (that's what she said), force yourself to really listen and respond with just a "thank you."

task sandwich

(task Sandwich)

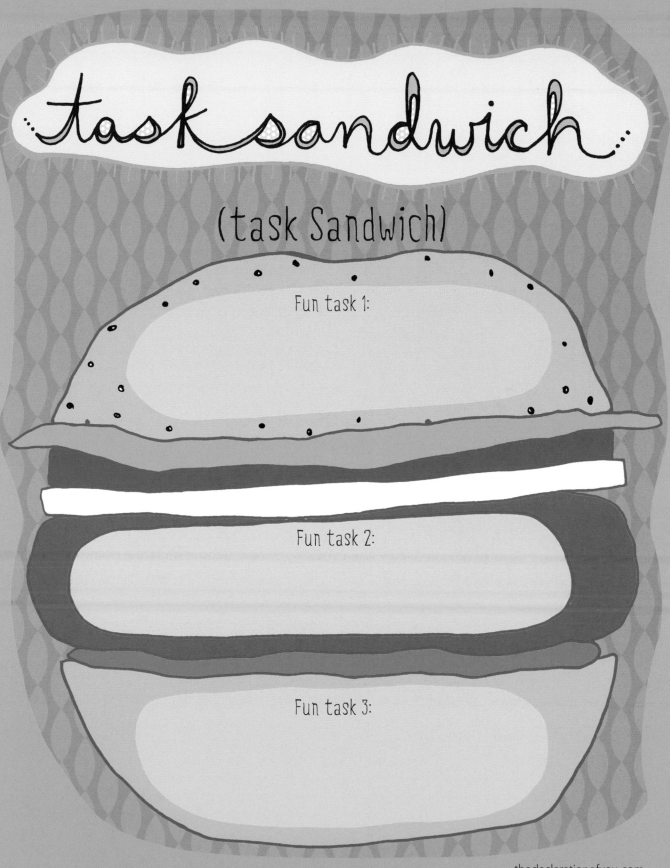

Fun task 1:

Fun task 2:

Fun task 3:

CELEBRATION (own it!)
Anahata Katkin

● ● ● ● ● ● ● ● ● ● ● ● ● ●

We just took one step at a time and believed in our vision along the way. It sounds simple, but it's really important to believe in what you're doing.

Each time we experienced something new, we used it as fuel and excitement for new dreams to unfold and new questions to be answered.

Each time we learn something new, it is a very rewarding victory. Because each time we answer questions and learn something new, it helps build onto our foundation. The more we learn, the more we're able to express ourselves as a company. Learning how to be good at what you offer and find what makes it special is very important chemistry. Going all out with that is what makes you different.

We have never been afraid to try new things, to go our own way and to give it everything we've got. Papaya! is a family-owned-and-operated company that employs dozens of talented, creative people who are responsible for what has become our company brand. It's no longer a two-woman job. There are many amazing people who make us what we are today.

TDOY: *You are the co-owner and primary artist behind Papaya!, a lifestyle, stationery, and gift company that makes the most gorgeous products ever. Can you tell us a bit about your journey so far and the ways you've celebrated the wild growth of your company along the way?*

AK: Papaya! Inc. started off as a small line of greeting cards that my mom and I adapted for print from my art journals over many years. Over time, the line has grown into a huge collection of lifestyle goods, a retail boutique, and we even just launched our clothing line, Leelah, in 2012! It's been a long and fluid process.

TDOY: *Your incredibly beautiful products and the messages they hold make it seem as though you celebrate each wild and delicious moment! How important do you think celebrating moments—both big and small, ordinary and extraordinary—is in creating a life that you love?*

AK: Well, I have been better at this at certain times in my life than others. It's a struggle for me to slow down enough to appreciate the lovely life around me. I think it's very easy for me to get caught up in the actions and the demands of life so that I miss the sweet details. But it's something I have been actively working on lately. I don't want to look back on

these years and dream of them. I want to experience them fully as they happen. It takes practice to get the most out of the good things you've created. Success isn't always felt as it's happening. You have to savor it and seek out the reality.

TDOY: *What's the most memorable celebration you can remember, and what made it so special?*

AK: My mom is the matriarch of our family and our business and our close community. She does so much for so many, tirelessly. I realized that she hadn't had a birthday party in a while and perhaps didn't even get the greatest of parties as a child. So I tried to think of her inner spirit and her more childlike side. I rented out our favorite restaurant and transformed the place with glitter, fancy pink and star balloons, giant pink lilies, banners, wind-up rabbits and a unicorn piñata. The place was glittering in pink blossoms and decorations. Forty people or so came and we surprised her. It was such a good moment to catch her off guard and shower her with the kind of love she gives to everyone else. I could just see it sinking in and how much it meant to her. And it meant the world to me.

TDOY: *You recently opened your first store in Ashland, Oregon. How did you celebrate such a milestone in your life and career, and did you take some time out to pause, reflect, and appreciate all the hard work that had come to fruition?*

AK: The celebration was, in fact, the store itself. It was immensely satisfying to go through the preparation phase, and opening the doors was a rich experience. It felt like I was able to drag all the details and inspiration and stories from my past out and share them through a visual story in the store. And there was so much satisfaction to know the risk was worth the effort—that I had been able to dream about something for all those years and manifest it the way I had imagined. I had some fears it might not be the magical place I hoped for. But in the end, watching your vision come to life is a powerful declaration of self-trust.

TDOY: *What's your personal declaration for celebration?*

AK: I am learning to appreciate the mile markers. I'd say I am still working toward a celebration declaration. But I love any reason to bring people together, to preserve memories, to thank myself for my efforts in private. I appreciate when I try new things and open up to new ways and people. As I get a little older, I get better at appreciating my limitations and my victories.

Anahata Katkin has developed her passion for the arts by trial-and-error discovery. Her work is a synergy between graphic design, painting and mixed media. Anahata has woven a heart-centered visual landscape of offbeat icons and illustrations that have comprised the prolific offerings of Papaya! Inc. since its beginning in 2003. Her style is easily recognized. Heavily influenced by antique ephemera, Asian traditions and an emerging global culture, Anahata's creative perspective remains progressive while absorbing gems from the past. Anahata currently serves as Artistic Director for Papaya! Inc. and Leelah clothing and is co-owner of Papaya! LIVING Luxe, Boho Boutique in Ashland, Oregon. You can learn more about Anahata at www.anahataart.com or www.papayaart.com.

CELEBRATION (own it!)
Susannah Conway

being an auntie and live for the sweet moments I share with my nephew.

I've learned that every single day I have is a gift, and because I don't know what tomorrow may bring, I try my best to live in the Right Now. Some days I manage to do this better than others, but when I remember to live as consciously as possible, even the small things like a really stellar cup of coffee are reason enough to celebrate.

TDOY: *Do you have any advice around how to keep celebration in your life during dark periods, while going through a traumatic event, or when it seems like the cup is half-empty? Do you think celebrating is at all an important part of the healing process?*

SC: It's very difficult to celebrate when you're going through a dark time, mainly because you lack the energy needed to feel hopeful or optimistic. I've endured several periods of depression in my life, and one of the things that's always helped me crawl out the other side is practicing gratitude.

A gratitude list is a tiny celebration written down on the page. It's the recognition of what is good in your life, even if it's just the toast you had for breakfast. When I'm in a bad place, I try to make the effort to list five things I am grateful for before I go to sleep—sometimes this means I write the same things for days in a row, but at some point there is a shift. Looking for the good—and acknowledging it in written form—helps my brain switch into a different gear. So while I may not have the energy for a big celebration, I'm creating my own pathway back to being able to do that.

TDOY: *You mention in your book and on your website that the man you loved died unexpectedly of a heart attack in 2005. We wonder, how has this experience changed and defined the ways you celebrate in your life?*

SC: Going through grief and bereavement changed every single part of my life. First I had to learn to live without the man I loved; then I had to learn how to make a new life.

One of the gifts that came out of that time was the understanding that life is short. It sounds like such a cliché, but you really do learn to appreciate life when you've faced down death (or illness or any other truly life-changing situation). So these days I celebrate being ALIVE. I celebrate my family and the love we have for each other. I celebrate

TDOY: *You run a wildly successful e-course called Unravelling in which thousands of women have participated around the world. How have you celebrated its success?*

SC: In June 2012 my first book was published. It's called *This I Know: Notes on Unraveling the Heart* and was partly inspired by my course. In July 2012, I went on a seven-city book tour across North America, meeting readers and doing book signings. One of the best parts of the tour was getting to meet women who have taken my class. Each book event turned into a mini-celebration of my course, too. It was humbling and amazing to meet so many people who had been touched by the course. I can't think of a better way to have celebrated the success of Unravelling!

TDOY: *In what ways do you make sure celebration is a part of your daily routine? (For example, do you schedule it into your calendar, or is it more spontaneous?)*

SC: I would love to be able to schedule celebration into my calendar—what a wonderful idea!—but, sadly, that doesn't happen. Instead, I just make sure I see my most important people as often as I can: booking in coffees and lunches with friends, weekends at my sister's house to spend time with my nephew (he is a celebration in a two-year-old's body) and the occasional getaway to somewhere new.

TDOY: *What's your personal declaration for celebration?*

SC: To me, celebration means appreciation, gratitude and love. I work really hard, so I try to remember to treat myself once in a while, gifting myself with little presents to bring some extra sweetness into my day. It could be a caramel latte, a new book or the occasional scented candle. Sometimes a hot bath is all the celebration I need at the end of a long, productive day.

Susannah Conway is the author of *This I Know: Notes on Unraveling the Heart*. A photographer, writer and e-course creator, her classes have been enjoyed by thousands of people from more than forty countries around the world. Co-author of *Instant Love: How to Make Magic and Memories with Polaroids*, Susannah helps others reconnect to their true selves, using photography as the key to open the door. You can read more about her shenanigans on her blog at SusannahConway.com and connect with her on Twitter: @SusannahConway.

CELEBRATION (make it!) Celebration Jar

We want to make sure you're celebrating the successes in your life, big and small, so what better way to do that than by making it fun and pretty? Use the celebration jar when you need a little help figuring out what you can do for yourself to make sure you're patting yourself on the back for a job well done. Put it in a place where you'll see it often, and stick your hand in every time you've reached a milestone, taken a step, or completed a task that you were procrastinating on—any time that calls for a celebration (or a bribe!), whether it's big or mini!

What You Need

- Mason jar (or any empty jar—an excuse to eat peanut butter and jelly sandwiches!)
- pretty paper (the colorful-er, the better)
- scissors
- markers
- ribbon
- tape or glue

1 Gather up your supplies. Be mindful to gather colors that you love that are celebratory to you.

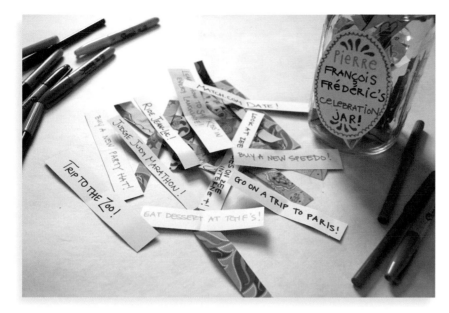

2 Cut the paper into strips. Size and shape are up to you, but make sure they're foldable so you won't see the writing when they're in the jar.

Using your markers (or crayons! or purple pens!), write a Celebration for every strip of paper. How will you reward yourself when you reach a goal, big or small? Those rewards should all be represented.

Fold the strips and put 'em in the jar. No peeking!

3 Decorate the jar however you'd like. You'll see here that we glued some ribbon to the top and attached a label to the front. But we love how the patterned scrap paper speaks for itself!

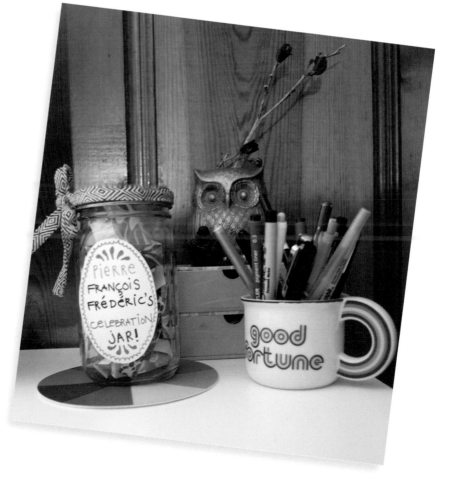

To watch our CELEBRATION video, go to www.createmixedmedia.com/thedeclarationofyou. (There's an audio version there, as well.)

DECLARATION 8

TrUST

TRUST
(discover it)

Michelle says—

I don't trust myself.

OK, that's not entirely true. I trust that I'm driven. I trust that I'm smart. I trust that I'm personable. I trust that I'm liked. I trust that I'm loved. But there are things that I don't trust because I've conditioned myself to not trust them. Don't trust that great audition! You probably won't get a callback. Don't trust the kick-ass callback! You probably won't get the part. Don't trust!

It's too scary. Trust disappointment, instead.

I don't trust that "it" will happen because I will it to. I don't trust The Secret. I don't trust that everything will work out. I don't trust that I know the things I should (I hate that word!) know. I don't trust anything beyond my control. And therefore . . . I don't trust myself.

But what I realized is that I know everything I need to know in order to continue on my journey. No, I don't have a crystal ball, but from the time I've been on this planet, I've succeeded, I've failed, I've loved, I've hurt, I've lost, and I've gained. I could go into details but, really, that's the gist.

What I see now in my crystal ball (maybe I do have one!) is this community I've built. Michelleland consists of not only the people I know and love, but people I trust, some of whom I see daily and some of whom I've never met. I realize I know everything I need to know, and that realization led me to unsubscribe from every newsletter by any person who didn't live in Michelleland. (I signed up for a trillion of them when

I launched When I Grow Up, believing that these people—y'know, The Ones Who Know Things—would tell me everything I should [there's that word again!] know. And it made me cluttered and slightly crazy. It sucked my time and my brain and my energy.) I was done listening to what I should know. I vowed to move forward trusting what I do know and asking for help with what I didn't. And that's made me see that everything that unfolds from this point on comes from trusting in Michelleland. I can believe in the people that make up Michelleland, and that makes me believe that I'm worthy of this trust, too.

Another mind-blowing trick that seems too good to be true, but really isn't: Really, truly, deeply, honestly start believing (you don't hafta wholly believe it—yet) that there are no such things as jinxes. Or bad luck. Or monsters. It's funny, because I used to be a waiting-for-the-other-shoe-to-drop girl. Something good just happened? Don't trust it! Something bad is right around the corner. And y'know what? When I look for the Bad Thing, I always find it. Always. What happens when you stop looking? What happens when you see that believing in the Vampires is simply a choice?

A good way to tap into what you can trust is to identify what you know. Really, truly, deeply, honestly know, from your own experience in your own life. Think of opinions that you consider to be more like facts, such as "Salted caramel pretzel ice cream is the best food ever invented," and all the lessons you've learned, like "The best person to care for me is me." Think big, think small, but just let yourself think outside the box when identifying what you know. (Michelle's note: Is your name Joe? A boat you will row! Sorry, I can't resist expanding on a rhyme.) (Jess's note: Oh, Michelle.) The What I Know worksheet is where you get to list all these Things You Know. It's totally fun. We promise.

If it feels like too big of a task, make it more of a stream-of-consciousness exercise by setting a timer for just five minutes and writing as much as you can in that time. Remember, no Know is too big or too small!

Now, does What You Know correlate in some way to what you're currently not trusting? Do you see a way to interpret your Knowingness (yes, that's a made-up word) to what you're trying to tackle now? Use the Current Fears worksheet to confront those Vampires by acknowledging and embracing the trust.

Is there a common thread in the right-hand column that you can summarize the best ways for you to trust? If not, think about what The Key is for you to trust yourself and the situation, and fill in your Declaration!

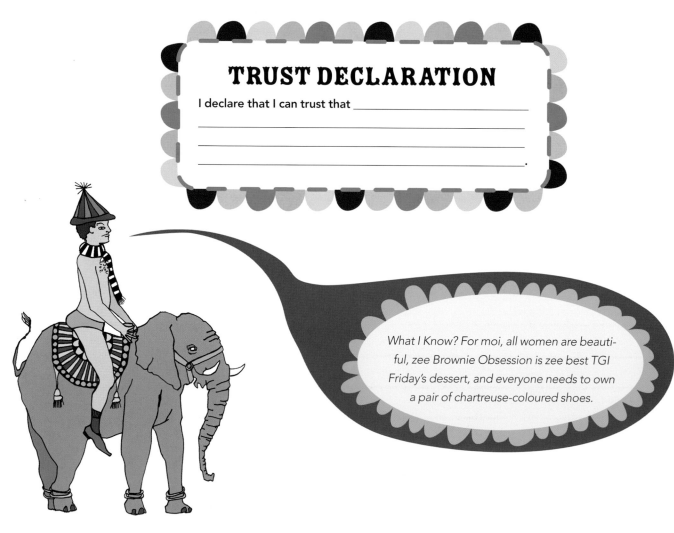

TRUST DECLARATION

I declare that I can trust that _____

_____ .

What I Know? For moi, all women are beautiful, zee Brownie Obsession is zee best TGI Friday's dessert, and everyone needs to own a pair of chartreuse-coloured shoes.

TOPIC:

What I know:

extra extra!

Elevator Speech

Nervous about how to describe your new goal, project, career, values and/or mission statement? We know—it's scary to stand up straight and tell the world what you're willing to believe! So, write an elevator speech. You have thirty seconds or less—the length of an elevator ride—to describe what you're doing. Imagine you're applying for a job and have to sell yourself to the potential employer. What do you say to make yourself feel proud, while grabbing 'em and pulling 'em in? Well, you talk up your strengths and your accomplishments, and you're not afraid to boast! Here's an example. (You can time this if you like. Our editor did and said it came in at 24.8 seconds!)

"I've decided to leave project management to pursue a lifelong dream of being a full-time artist! I opened up an online shop so people can buy my paintings, and I just secured a booth to sell my stuff at the Brooklyn Flea, which is consistently winning Best Of awards. I'm just starting out, but I already made my first sale and have incorporated myself, so I'm on my way! I'm so happy to work for myself and pursue a career I'm really passionate about."

When you think it's "right" (it's in quotes because there's no one way to be right!), read it out loud to make sure you're comfortable with it. Then, when you know it sounds and feels natural, practice it a few times so the key points stick in your head. You don't have to memorize it and recite it like a robot, but we bet the Girl Scouts slayed some vampires by sticking to the motto: Be prepared!

Taking Risks

Make a list of all the things that are scaring you, along with the possible downfalls of each risk, the possible rewards for those risks, and why you want to take these risks (not why you should!). Pick the least scary thing from that list and commit to taking a tiny baby step. Remember, your legs are there to pick yourself back up.

Dream Big

How would you face your fear and achieve your dream in a perfect world? Now let yourself daydream (or journal or paint or write a song) about what it would be like to audition for that band or leave that job or work with that dream company. If you weren't scared, or didn't need to worry about money, how would you do it? And don't let yourself stop at, "I'd open a theater and cast myself as the lead in everything. Duh, guys." Think of the steps you'd need to take to open the theater, and why that would be the answer in the first place, and what you'd get out of that experience. See the big picture and then focus on the details. Who knows what can be translated to The Real World?

To watch either MICHELLE'S or JESS'S "Following My Path" videos, go to www.createmixedmedia.com/thedeclarationofyou. (There are audio versions there, as well.)

TOPIC: Current Fears

What I'm currently fearing:	How I can trust it:

TRUST (own it!)
Danielle LaPorte

TDOY: *You've had quite the exciting and varied career so far, ranging from running a think tank in Washington, D.C., to running your own communications agency, co-authoring a book about style to writing a stunningly successful e-program and book that are revolutionizing the way entrepreneurs interact with their businesses. Can you tell us a bit about that?*

DL: The short version is that I wrote a book called *The Fire Starter Sessions*, which was inspired by me getting canned from a major company that I co-founded. In order to make money after I got canned from my own job, I went to sixteen cities that same year and sat in people's living rooms

and board rooms and pole dancing studios and jammed with them about being sincere, being authentic—that place where ambition meets meaningfulness in your life and making money in ways that matter to you. As a brand, people have said, "She's about a lot of tough love with a lot of extra love."

TDOY (Jess): *I participated in a group Fire Starter Session that you led in 2009, and something you said struck me at the time and has stayed with me ever since. You said that we already have all the answers for ourselves, and all we have to do is listen. So many of us feel incomplete or lacking somehow, and we look outside ourselves for answers about our lives. What would you say to someone who believes the answers she's searching for are outside rather than within herself?*

DL: Deny your heart at your own peril. I think so many people feel like they know; they really just need someone to give them permission. I've been thinking a lot about this lately, and I think in some ways it's OK to want someone else to validate your desires. It's so easy to say it's weak and you shouldn't look outside, but we live dynamically. We want to know if our idea's good or if something's going to work in the marketplace; if we're being seen, felt and heard. But I think we need to be more compassionate with ourselves when it comes to looking outside. And after that compassion, at the end of the day—absolutely, positively, entirely—you're the one who calls the shots on everything in your life, and everything is a choice. Everything, everything. You choose how you feel. You choose how you respond to challenge. You choose how you respond to love. You choose everything that goes into your body. And thinking that you don't have a choice is the beginning

of life tragedy. But in order to have the courage to make those choices, you need to trust.

And what I have to say about trust is this: There are two sides to it, and I think we criticize ourselves a lot in our sort of new-age, motivational, self-help conversations and cultures when we don't trust. Like, I should be more faithful to my God. I should be more confident about what I'm doing. I should be unwavering. And that is kind of cruel, in a way, to ourselves. So, I think we need to get off our own cases during the times when we have doubt. I think if you're alive, it's going to creep up. Nobody said that trusting is going to be easy. The concept of faith implies that there's going to be some resistance. There's a reason to have to trust.

I also love worst-case scenarios. If you go bankrupt, it ain't going to kill ya. If you lose your coaching clientele because of some scandal, you can hustle. So before I start anything, I think, "What's going to happen if this bombs?"

TDOY: *We love your idea of the Stop Doing list, where you eliminate the things in your life that you resent. How can we trust that it's OK to let go of those things that we feel are "shoulds?"*

DL: When you hate it, when you're seething with resentment, you need to stop doing it. And the mind game you can play with yourself in a healthy way is to say, "By continuing to do what I don't want to do, I'm not being as productive, and I'm not letting my great future happen." You really need to see the downside and the damaging effect of doing shit that you don't want to do. Sometimes that'll be what shakes you out of it.

Resentment never ever turns around. Things will only change if you change them, but if you're doing something that you are pissy about, and you think it's going to have a great result even if you hang in there a long time, it just doesn't. It's sour fruit.

When you do what's easy for you, it energizes you. It makes your skin clear up. You think mo' better. And therefore, by doing what's easy for you, you can be more useful and of more service to other people. My theory is that easy is actually very productive and it puts you in that place where you get momentum. Doing what's easy, what comes naturally to you, what's simpler, takes trust.

TDOY: *Was there a time in your life when you weren't living guided by your intuition or your heart, and if so, was there a turning-point moment for you when you realized you weren't living the way you wanted to live?*

DL: I haven't always been this evolved. When I got canned from my corporation, I realized I had been inauthentic and quiet for a long time. The more money that came to the table with investors, the more people that got involved, the more quiet I became. There was a direct ratio.

I got a big smack.

But at the time, I also felt an immediate sense of freedom. So much of me was like, "Yes. Finally. Awesome." And I vowed to never dummy down and never keep my mouth shut ever again.

TDOY: *What's your personal declaration for trust?*

DL: My declaration of moi is that everything is progress. I can just throw my hat into that ring of faith, that pure, blind faith, because believing that and trusting that everything is progress feels good. And also I have some science to back me up. Any astrophysicist will tell you that, scientifically speaking, the universe is always expanding. It's proven. It's constantly growing. And we are part of the universe. That includes us. Even backward is forward.

Danielle LaPorte is the author of *The Fire Starter Sessions: A Soulful + Practical Guide to Creating Success on Your Own Terms.* An inspirational speaker, former think tank exec and business strategist, she is the creator of the online program, The Spark Kit: A Digital Experience for Entrepreneurs and co-author of *Your Big Beautiful Book Plan.* More than a million visitors have gone for her straight-up advice on DanielleLaPorte.com, a site that has been deemed "the best place online for kick-ass spirituality." You can find her on Facebook and on Twitter @daniellelaporte.

To listen to an extended video interview with DANIELLE LAPORTE, go to www.createmixedmedia.com/thedeclarationofyou.

TRUST (make it!)
Vampire Mask

● ● ● ● ● ● ● ● ● ● ● ● ● ● ●

We know this is a silly exercise, but we hope that by seeing yourself in your Vampire mask, you realize that the Vampire isn't *you*, and you don't need to listen to it!

When you're done, take a photo of yourself wearing the mask, print it out, and paste it in the lower portion of the first Conversation With Your Vampire worksheet. Use the speech bubbles to write what your Vampire tells you in order to suck the good stuff right outta ya.

Then, find a picture of your cute self (sans mask) and paste it in the lower section of the second Conversation With Your Vampire worksheet. Use the speech bubbles on that worksheet to counter-argue your Vampire (and shut him/her up in his/her stupid Vampire face!)

What You Need

- cardstock or construction paper, 2 letter-size sheets
- markers
- scissors
- pencil
- stapler or tape

1 Start with a full sheet of construction paper or cardstock. Draw a V somewhere in the middle of page big enough for your nose to fit through.

2 Cut along those lines. (To cut in the middle of the page, fold it in half gently.) Stick your nose through and use your index fingers to gently dent the paper to mark where your eyes are.

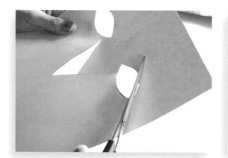

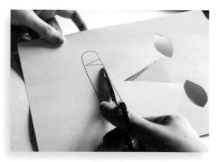

3 Use a pencil to draw an eye shape of your choosing around the marks. Cut along these lines to create your eyes.

4 Put the mask back on and make sure you can see out of it. If not, re-cut the eye holes to make them bigger.

5 Draw a mouth (fangs optional but encouraged) and cut along those lines.

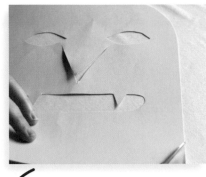 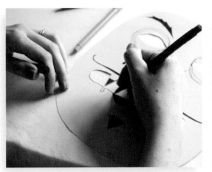 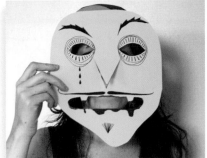

6 Round the four corners of the page with your scissors to make the mask more oval-shaped (like your face).

7 Use your markers to draw what your Vampire looks like. Embellish as much or as little as you want.

8 Hold the mask up to your face and see how it looks.

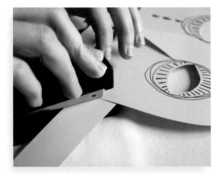

9 Cut two strips of cardstock to make a strap. Flip the mask over and staple or tape one strip to each edge of the mask, around ear level. Once both sides are in place, hold the mask up to your face and wrap the strips around to fit your head, overlapping them until there's a nice fit. Staple or tape the strips together to secure.

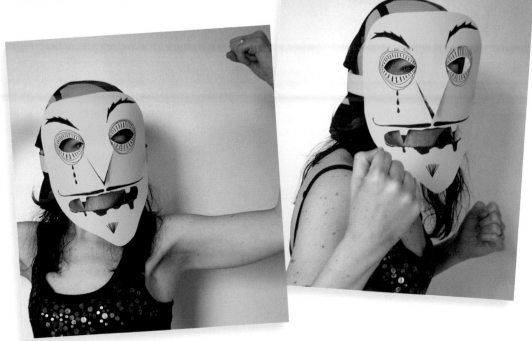

To watch our TRUST video, go to www.createmixedmedia.com/thedeclarationofyou. (There's an audio version there, as well.)

CONVERSATION WITH YOUR VAMPIRE

Conversation with your Vampire- write what your vampire says to you in these bubbles:

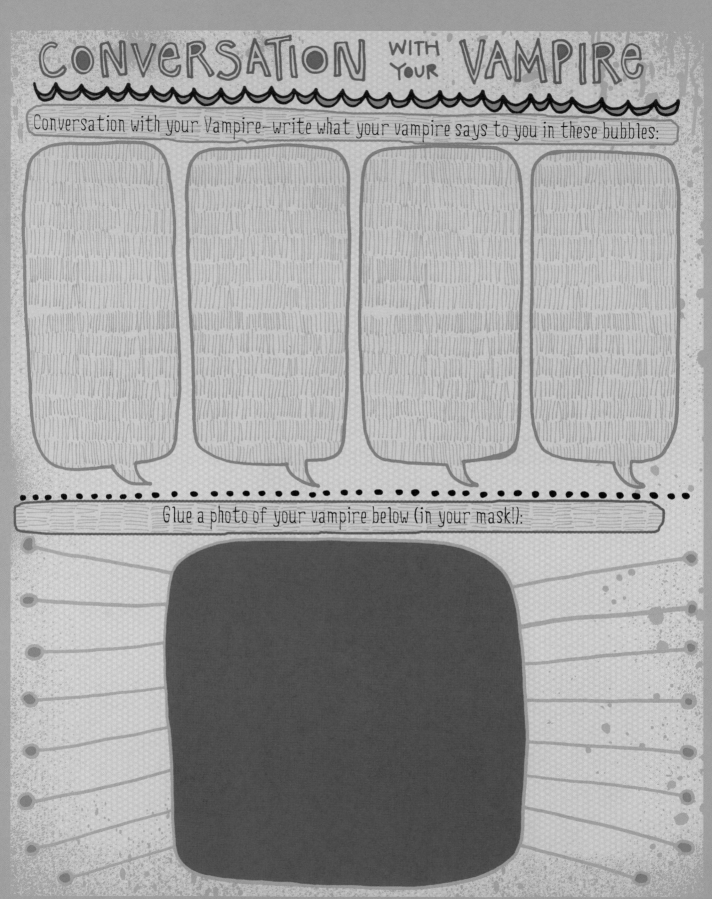

Glue a photo of your vampire below (in your mask!):

CONVERSATION WITH YOUR VAMPIRE

Conversation with your Vampire—write what you say to your vampire in these bubbles:

Glue a photo of yourself below (No Mask!):

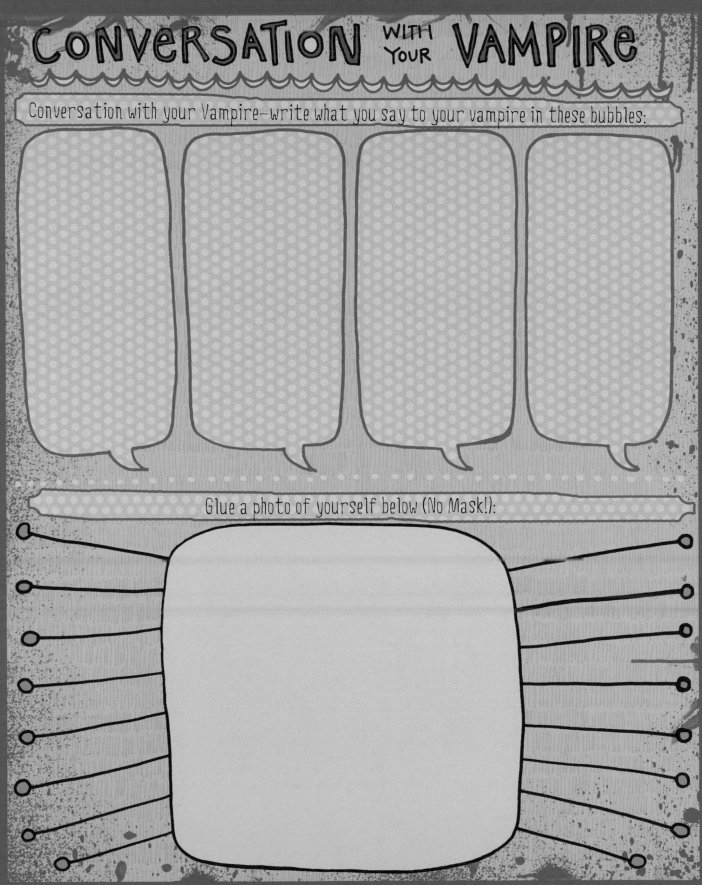

SHOUT IT ●●●●●●●●●●●●●●●●●●●●●●●●●●●
(now make it happen!)

And finally, what you've been working so hard for!

Congratulations!
Mazel tov!
Felicidades!
Applause!
And the crowd goes wild!

You freakin' did it. That is amazing. You made the time, had the patience, kept your sense of experimentation and fun, defaced the pages, dug deep under the surface, confronted (and slayed) your Vampires, discovered (and celebrated) your uniquity, and you created a freakin' **Declaration of YOU**, for Pete's sake.

It's now time to do what you've been working toward through these last eight chapters: Filling in your final Declaration of You. It's waiting for you on the next page, with spaces to add the declarations you crafted from each juicy chapter. Hooray!

Now the United States isn't the only country that has a declaration. YourNameHereLand has one, too. You can sense what's coming, right? We know, we know, you worked so long and so hard and yet . . . your work isn't done. You have your Declaration, but is it going to do you any good staying between these pages? Is it going to be your constitution if you don't actually put it into practice? No, you don't have to build a Congress or a House of Representatives, but it's now time to give thought to the well-thought-out and brilliant tagline of this fantabulous workbook (if we do say so ourselves) and step into your Declaration.

The shouting comes afterward. What does "step into" mean, anyway? Like a new pair of pants, you need to see where they fit into your wardrobe, break 'em in, and walk around in 'em. Use the Making It Happen worksheet to declare (yes, declare!) the ways you can adapt your Declaration to your real life, and then check off which ones you're actually going to commit (not try!) to putting into practice.

THIS IS _____'S DECLARATION!

Sum up your resolutions!

ENTHUSIASM

UNIQUITY

INTENTION

SELF-CARE

SUCCESS

MONEY

CELEBRATION

TRUST

thedeclarationofyou.com

And don't forget that the experiment and fun don't end here! This commitment does not need to be forever or even 'til next month. Simply step into it. See how it feels. Notice if it needs to be altered or hemmed. Then wear it, and make it a staple piece in your wardrobe.

Then you can shout it from the rooftops, whether your rooftop is a phone call to your mother or a huge party with your Declaration as the top of a big sheet cake. At the very least, point your megaphone in our direction at www.thedeclarationofyou.com. Because we're coolaborators, remember?

Mark this day in your calendar and all calendars to come. If you ever wanted a key to a city or a street named after you or an entire day in your honor, here it is. Your own Declaration-of-You Day. Don't take for granted that your Declaration of You will stay the same year after year because, well, you won't stay the same year after year (or week after week or even day after day). Use your annual Declaration-of-You Day to open up this book and revisit your declaration from the previous year to be read, thought about, and maybe even worked through once more. It's an ever-changing, ever-evolving process.

And so are you.

TOPIC: Making It Happen

What I can do to adapt my declaration into my life:	Committed!:

Index

Dedication

To those of us who delight in exploring life playfully, colorfully and quirkily. Here's to finding and celebrating our differences and our uniquity. This book is for you!

Acknowledgments

Love to our Declarers, whose participation throughout The Declaration of You e-courses shaped this work into what it is today. Thanks for allowing a Frenchman who loves Judge Judy to help you along your way.

Much love and appreciation to Ryan Swift. Had we listened to you, this book would never have been possible. Thanks for sharing your opinions with us and allowing us to blatantly ignore and mock them. We love you!

Apologies to Luke Ward for being forced to give Pierre voice and movement. We're glad you love us despite the torture we put you through, and we look forward to touring together with you in the Pierre mascot character costume. We hope that dinners from Brooklyn Public House are payment enough.

Massive thanks to our editor, Tonia Jenny, for believing in our vision and helping us easily and enthusiastically deliver it to the world!

And love to each other. Best partnership ever! Okaaaaaaaay?

www.fwmedia.com

Published by North Light Books, an imprint of F+W Media, Inc., 10151 Carver Road, Blue Ash, Ohio 45242. (800) 289-0963. First edition.

17 16 15 14 13 5 4 3 2 1

Distributed in Canada by Fraser Direct
100 Armstrong Avenue
Georgetown, ON, Canada L7G 5S4
Tel: (905) 877-4411

Distributed in the U.K. and Europe by F&W Media International
Brunel House, Newton Abbot, Devon, TQ12 4PU, England
Tel: (+44) 1626 323200, Fax: (+44) 1626 323319
E-mail: enquiries@fwmedia.com

Distributed in Australia by Capricorn Link
P.O. Box 704, S. Windsor, NSW 2756 Australia
Tel: (02) 4560-1600
Fax: (02) 4577-5288
E-mail: books@capricornlink.com.au

ISBN-13: 978-1-4403-2466-6

Editor: Tonia Jenny
Illustrator: Jessica Swift
Designer: Amanda Kleiman
Production Coordinator: Greg Nock

ABOUT JESS and MICHELLE ● ● ● ● ● ● ● ● ● ● ●

Jessica Swift

Jessica Swift is a full-time artist and pattern designer and is on a quest to inspire everyone on the planet to pursue their wild + colorful dreams. . . and never give up. Her colorful, uplifting artwork is licensed by companies and manufacturers for iPhone cases, fabric, stationery and much more. Her art and products are designed to serve as tokens of happiness—reminders that you need (and deserve) to feel GOOD in your life. She lives in Portland, Oregon with her husband and two adorable cats, and you can find her colorfully creating and blogging online at JessicaSwift.com.

Michelle Ward

Michelle Ward (aka, the When I Grow Up Coach), PCC, has coached hundreds of creative types to devise the career they think they can't have or to discover it to begin with. She's a Professional Certified Coach by the International Coach Federation, a musical theater actress with her BFA from NYU-Tisch, and a corporate America escapee. Michelle lives in Brooklyn, New York, with her husband, Luke, her ukulele, Lucille and their Roomba, Jeeves. You'll find her coachin', singin' and bloggin' at WhenIGrowUpCoach.com.

Jess and Michelle are in love.
This is their first book.

Join the creative community at CreateMixedMedia.com!

creative techniques · projects · e-books · shop · book reviews

Inspire your creativity even further with these North Light titles.

 Follow us!
CreateMixedMedia

 Follow us!
@CMixedMedia

f Follow CreateMixedMedia for the latest news, free demos and giveaways!

CreateMixedMedia.com

Connect with your favorite artists.
Get the latest in mixed-media inspiration.
Be the first to get special deals on the products you need to improve your mixed-media endeavors.

 For inspiration delivered to your inbox, sign up for our free newsletter.